YELLOWSTONE

A LAND OF WILD AND WONDER

CHRISTOPHER CAUBLE

RIVERBEND
PUBLISHING

Yellowstone: A Land of Wild and Wonder
Copyright © 2016 Christopher Cauble, www.caublephotography.com
Published by Riverbend Publishing, Helena, Montana

Design by Sarah Cauble, www.sarahcauble.com

ISBN 13: 978-1-60639-092-4

Printed in India

Distributed by NATIONAL BOOK NETWORK

Riverbend Publishing
P.O. Box 5833
Helena, MT 59604
www.riverbendpublishing.com

Front cover photo: Boardwalk, Upper Geyser Basin
Back cover photos: Thermal pattern at Grand Prismatic Spring, bull elk
Title page photo: Gull Point on Yellowstone Lake

In Memory of
Samuel Cooper Howell Sylvester

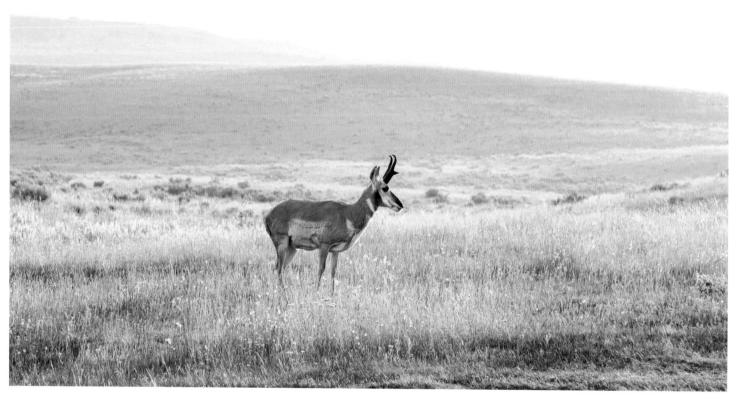

PRONGHORN

INTRODUCTION

BY CHRISTOPHER CAUBLE

Growing up in Montana, some of my earliest memories were family trips to Yellowstone. We hiked along snowy Slough Creek; backpacked into the isolated Thorofare country; and fished for cutthroat trout deep in the canyons of the Yellowstone River.

Whether it was exploring the gravel shoreline of Yellowstone Lake or the late nights looking up at the stars next to a warm campfire, Yellowstone always filled me with a sense of wonder.

As I grew older, my fascination with the park became a journey of discovery. I came to understand how the natural environment changed as the seasons turned, and I began to see the interwoven patterns of plants and wildlife in a fully functioning, wild ecosystem. I began to see Yellowstone in an intimate way.

After many years of exploring and photographing Yellowstone, I learned, as so many people do, that there's nothing quite like it in the world. The wildlife, geysers, mountains, and rivers all blend to make it a truly special place, a unique whole of wild and wonder.

No matter how many days you spend in Yellowstone, there's always something new to see. Each morning there is excitement and anticipation about what the day will bring. I hope these photographs instill a sense of wonder, and perhaps become part of your Yellowstone discovery.

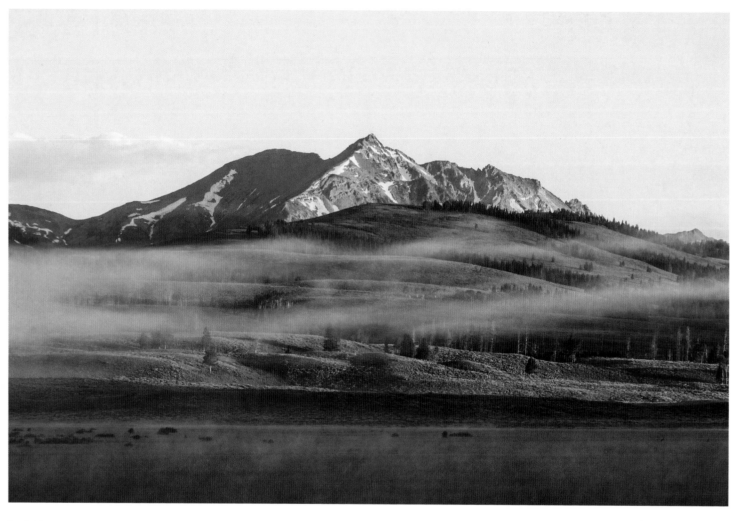

ELECTRIC PEAK

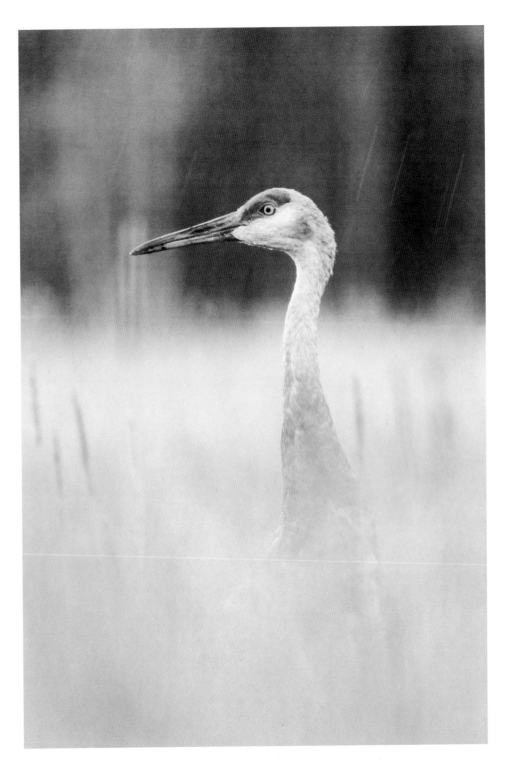

SANDHILL CRANE

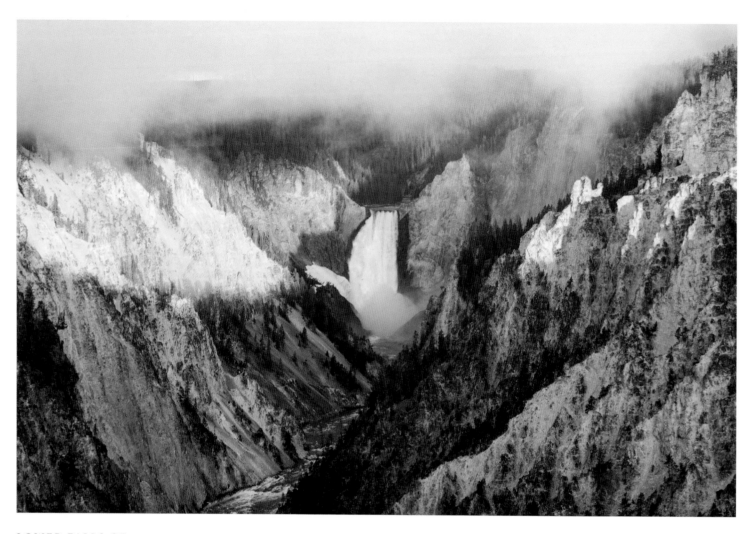

LOWER FALLS OF
THE YELLOWSTONE RIVER

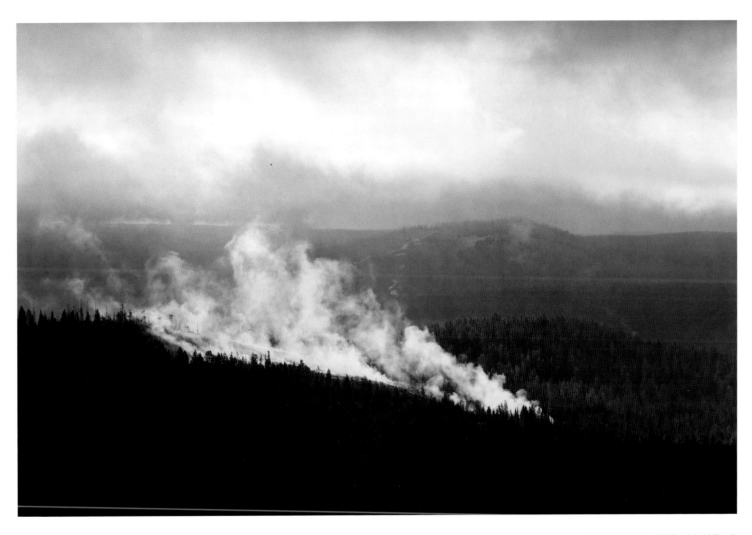

THERMAL STEAM NEAR
MOUNT WASHBURN

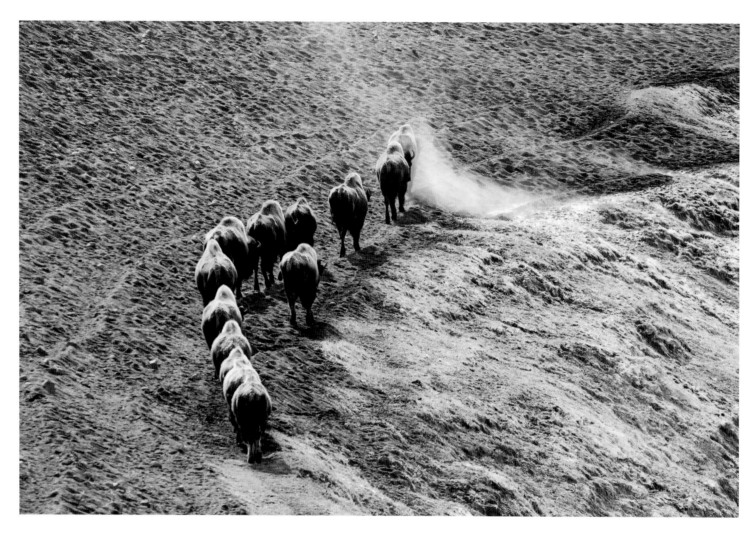

BISON AT MIDWAY GEYSER BASIN

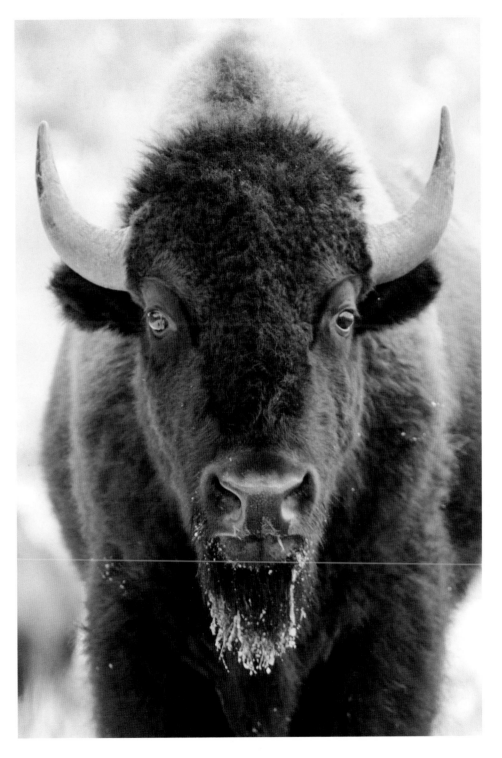

BISON

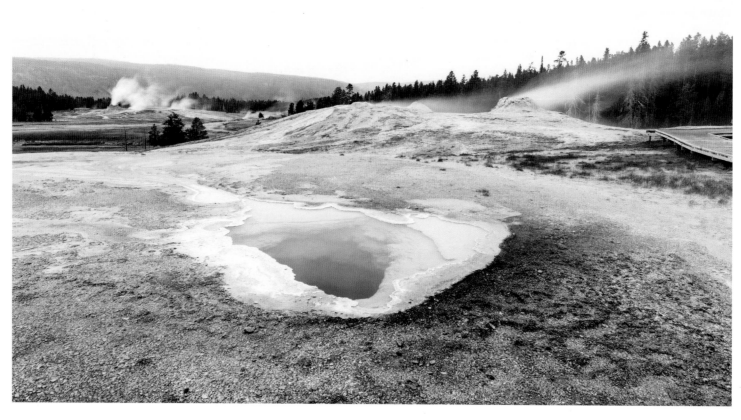

HEART SPRING,
UPPER GEYSER BASIN

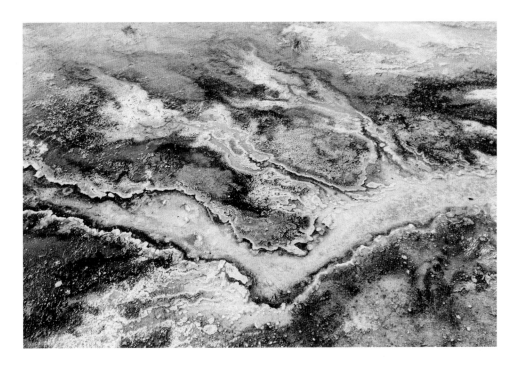

THERMAL PATTERN IN
THE UPPER GEYSER BASIN

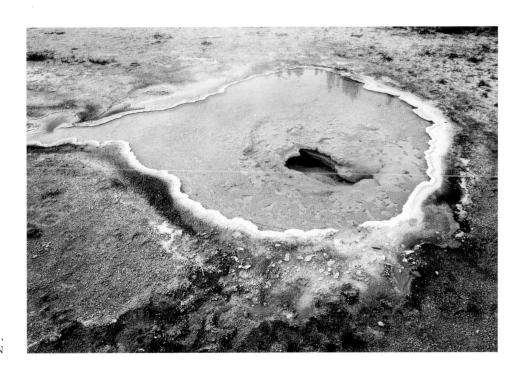

PENDANT HOT SPRING,
UPPER GEYSER BASIN

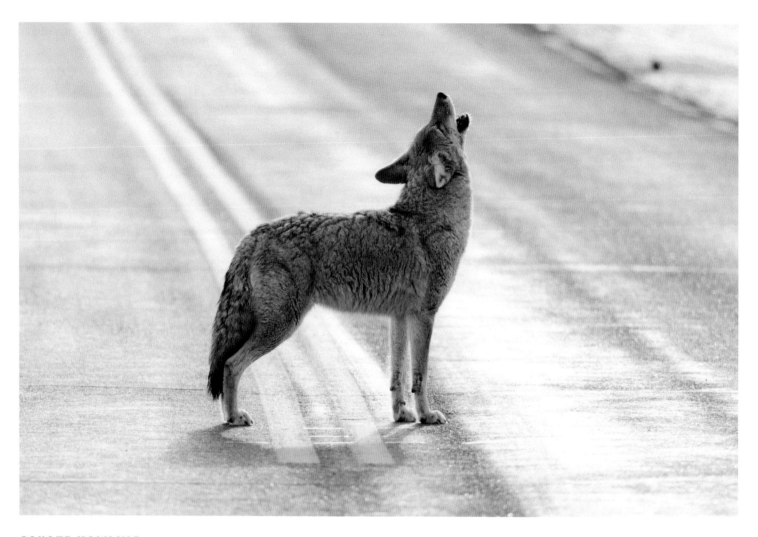

COYOTE HOWLING
AT TOWER JUNCTION

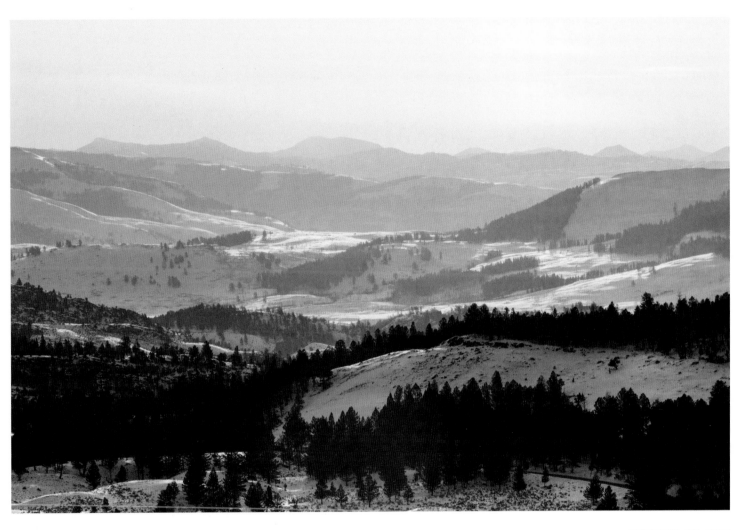

WINTER IN THE
NORTHERN RANGE

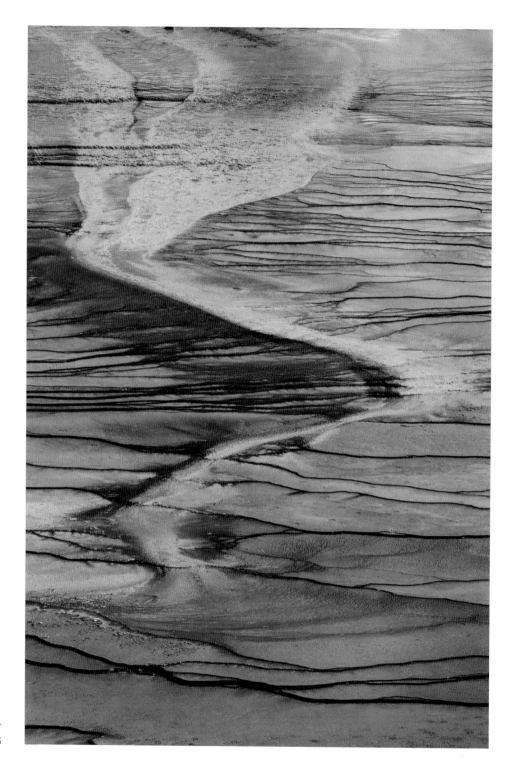

THERMAL PATTERN AT
GRAND PRISMATIC SPRING

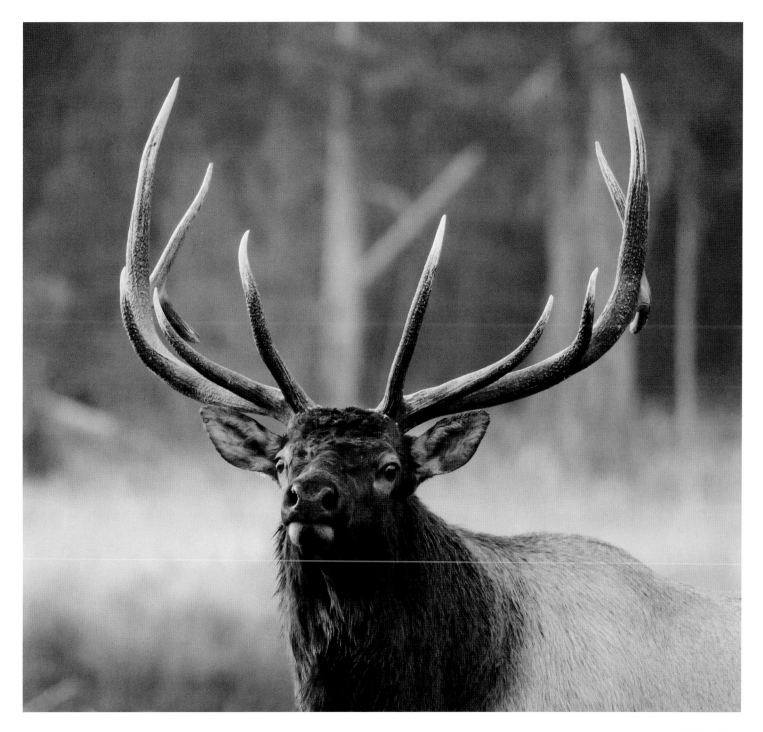

BULL ELK

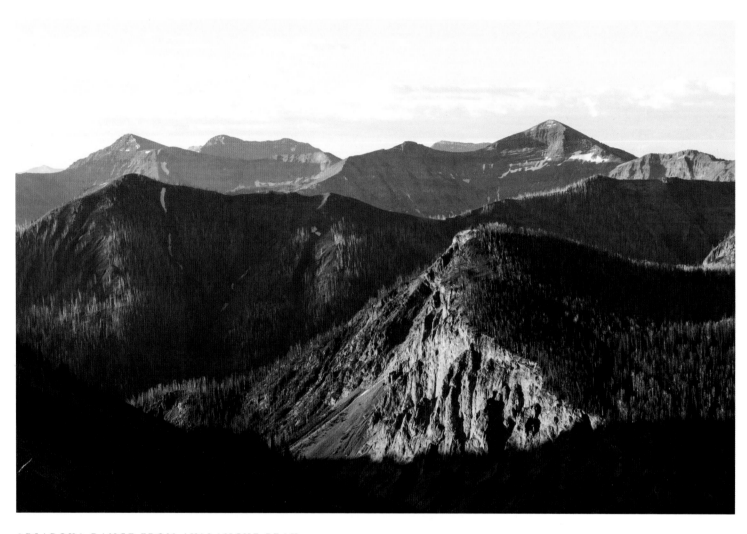

ABSAROKA RANGE FROM AVALANCHE PEAK

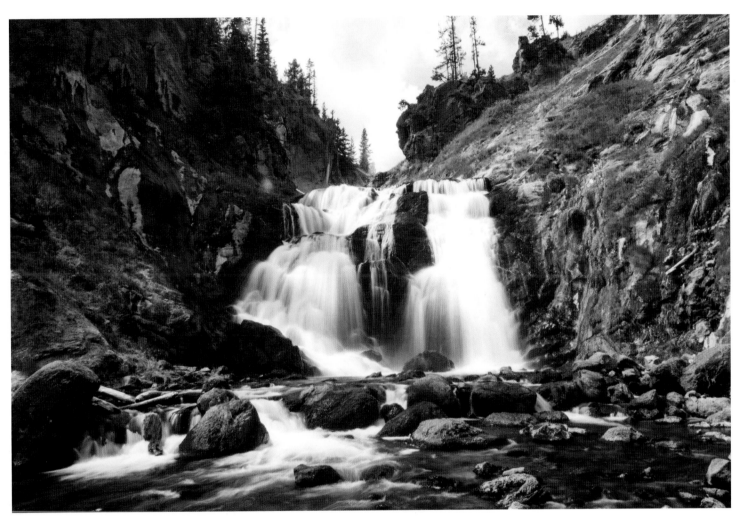

MYSTIC FALLS

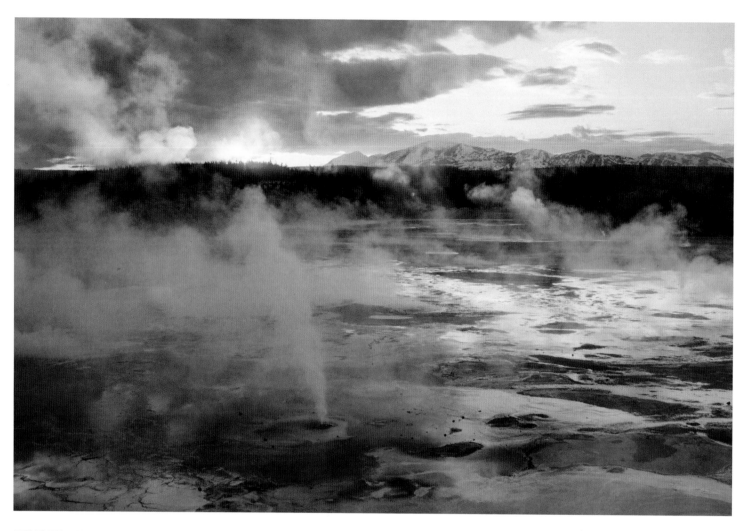

SUNSET AT PORCELAIN BASIN,
NORRIS GEYSER BASIN

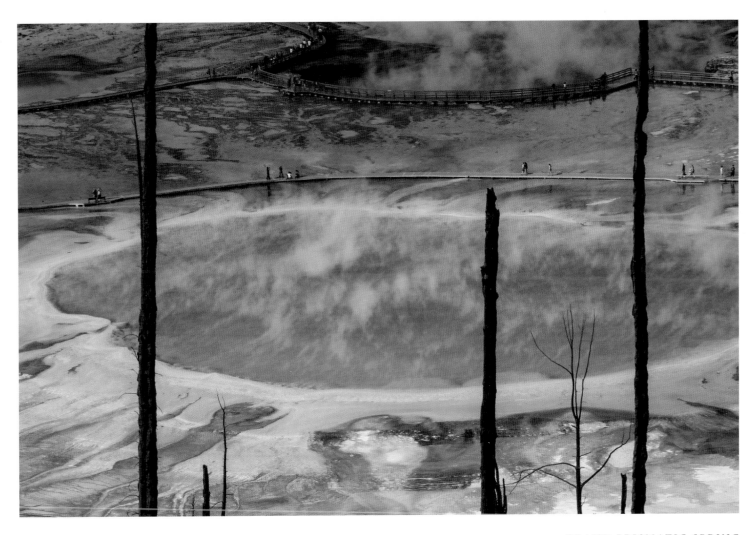

GRAND PRISMATIC SPRING
FOLLOWING PAGES: BLACK POOL,
WEST THUMB GEYSER BASIN

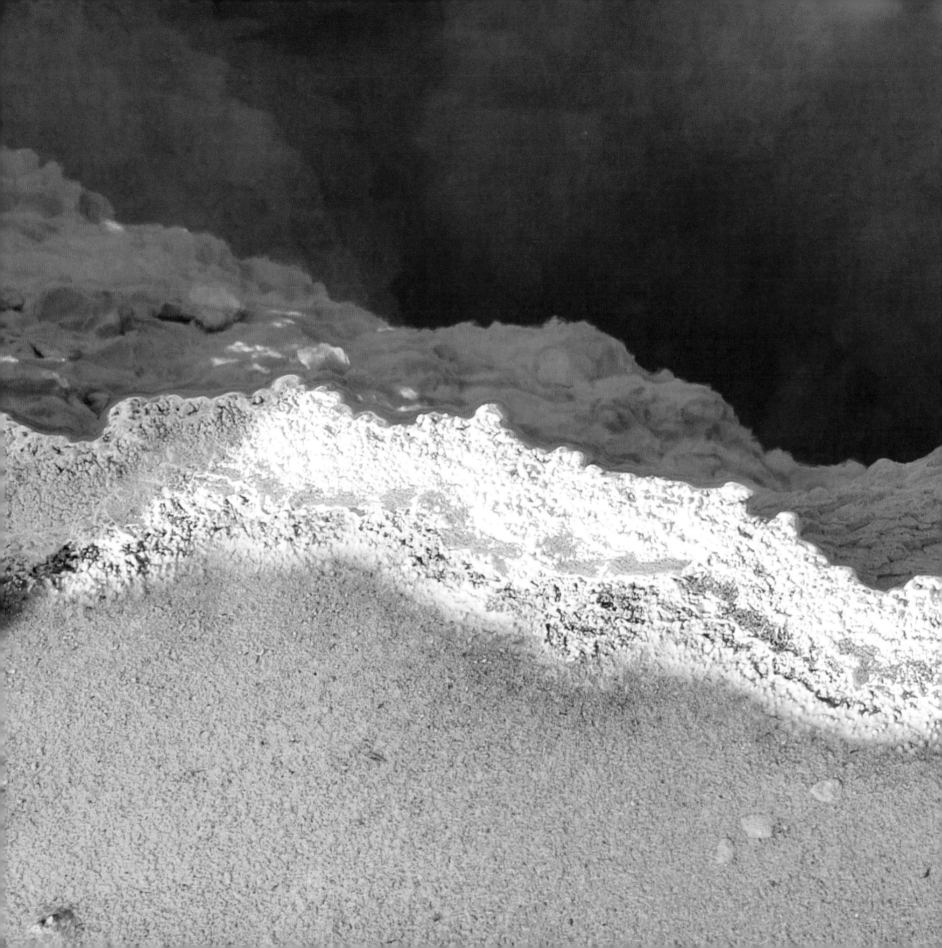

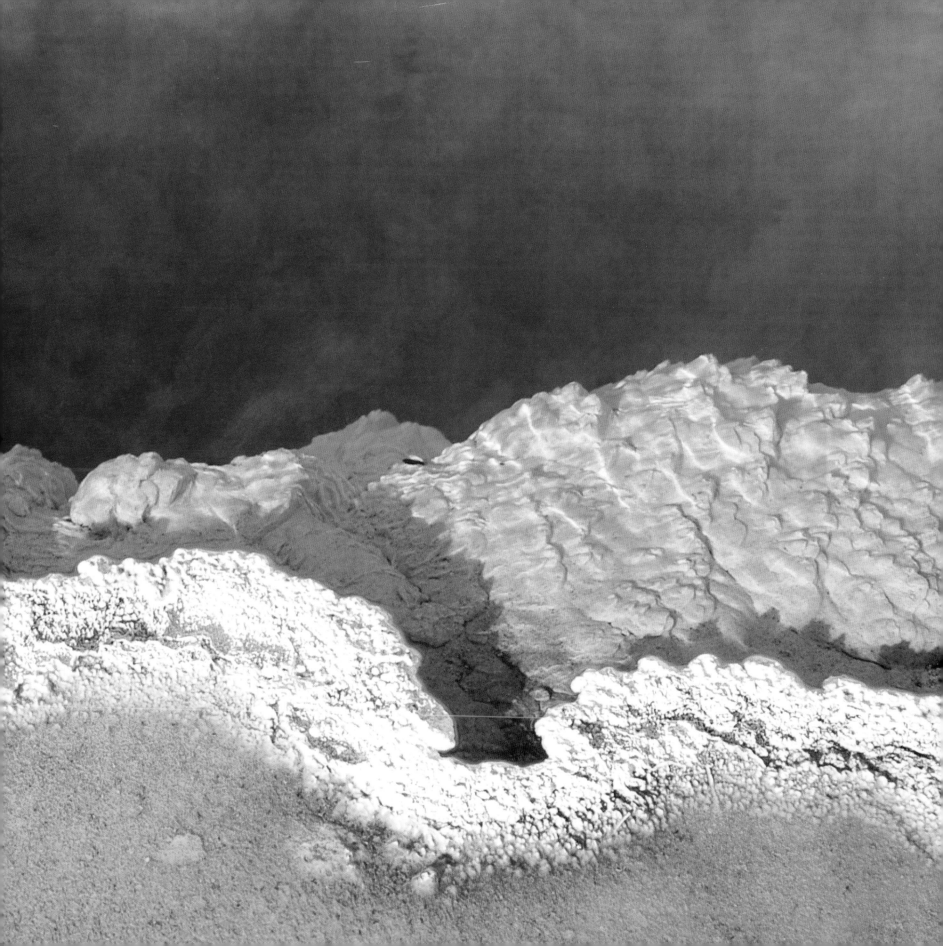

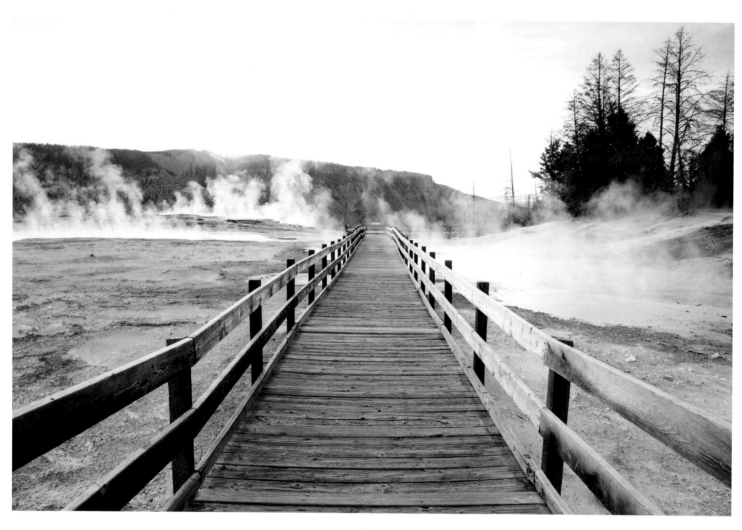

BOARDWALK, MAMMOTH HOT SPRINGS

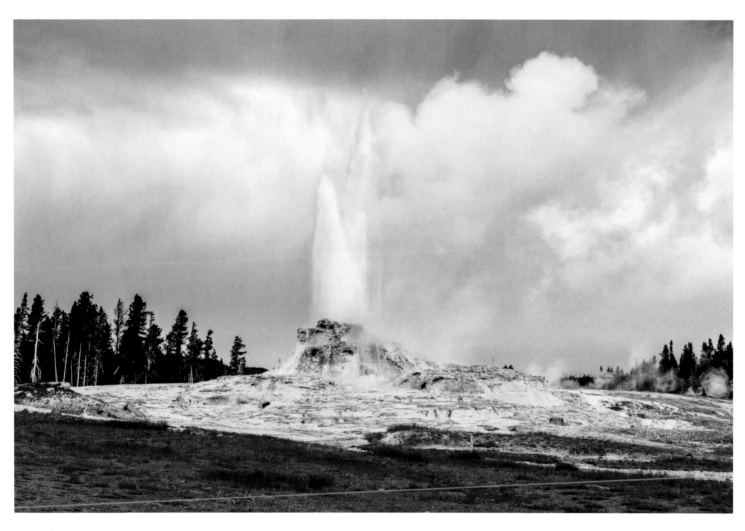

CASTLE GEYSER, UPPER GEYSER BASIN

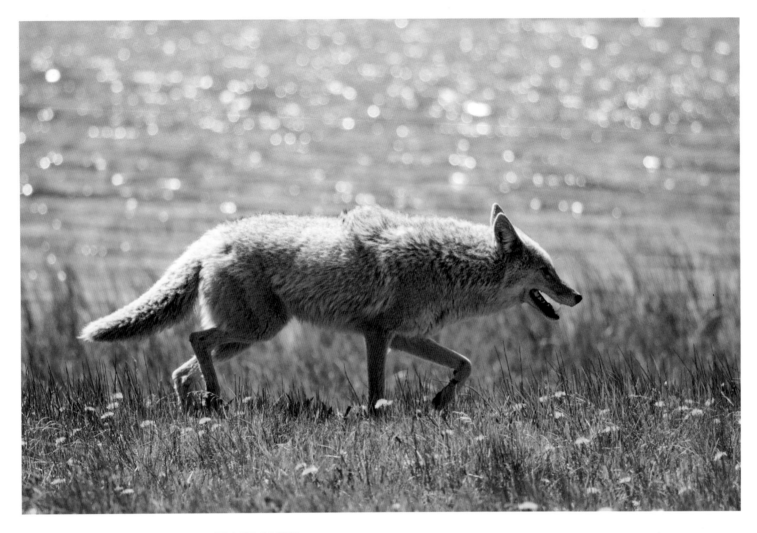

COYOTE ALONG THE YELLOWSTONE RIVER

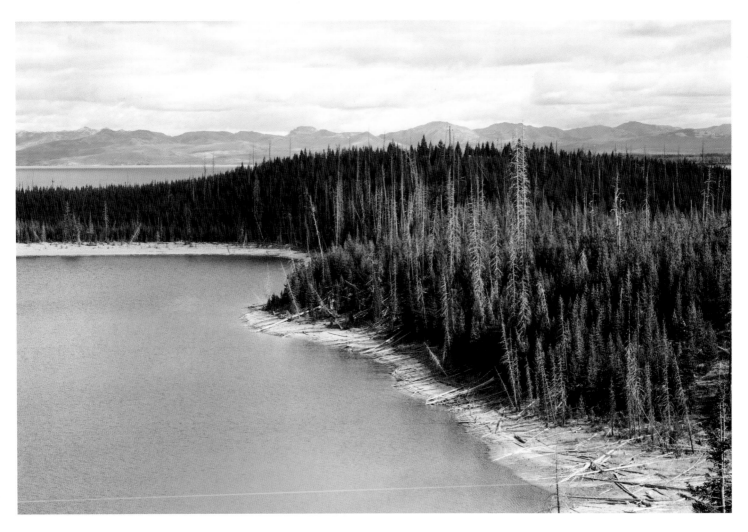

DUCK LAKE

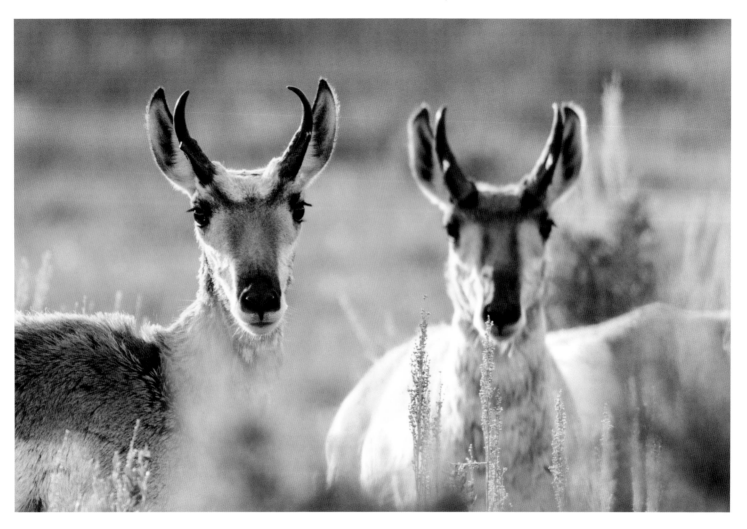

PRONGHORNS

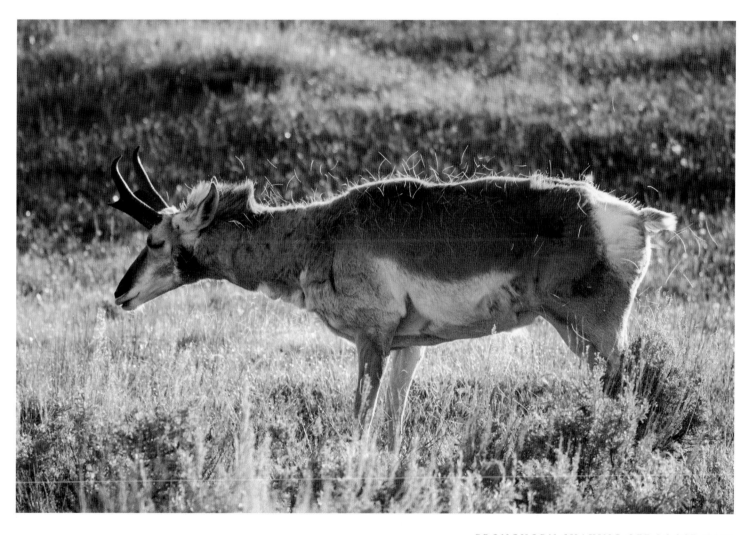

PRONGHORN SHAKING OFF LOOSE HAIR

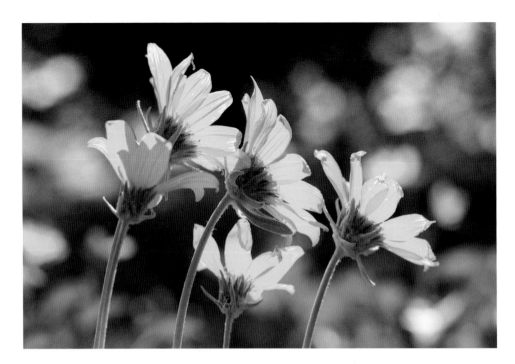

ARROWLEAF
BALSAMROOT

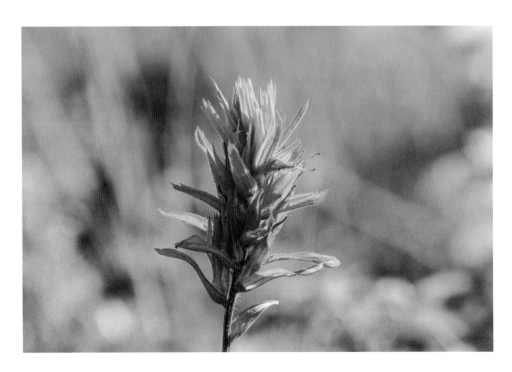

INDIAN
PAINTBRUSH

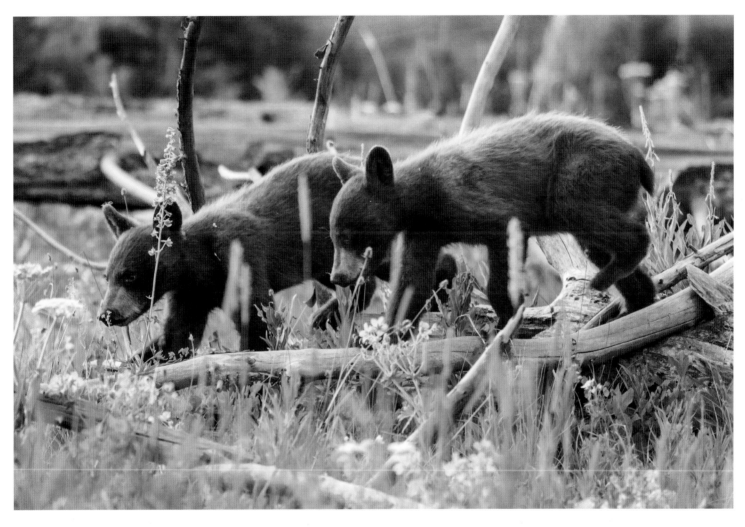

BLACK BEAR CUBS

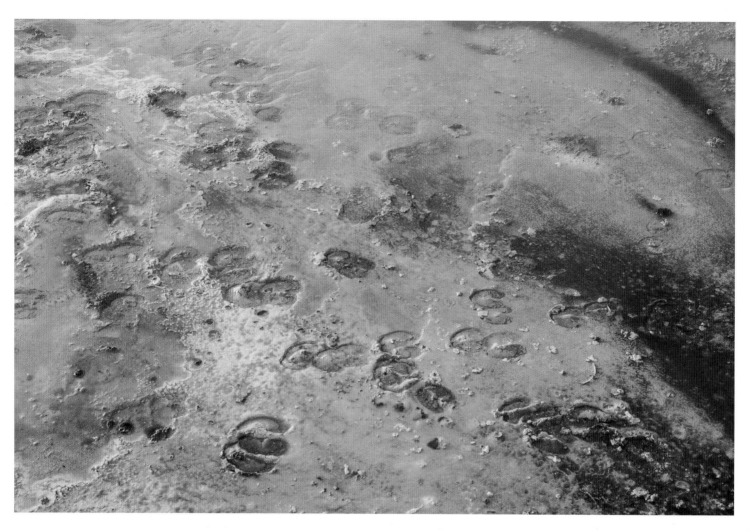

BISON TRACKS IN BISCUIT BASIN

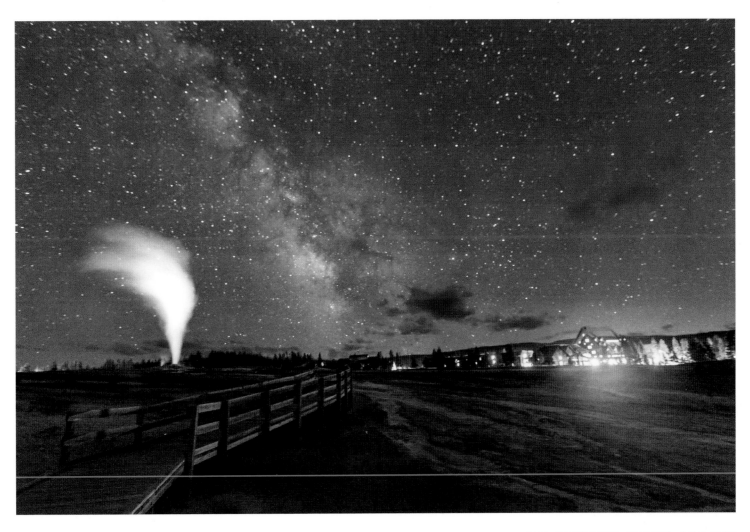

OLD FAITHFUL GEYSER AND INN
UNDER THE MILKY WAY

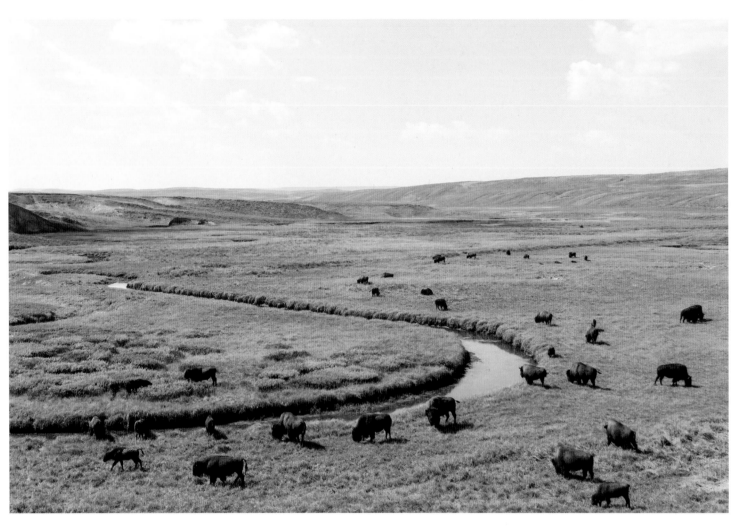

BISON IN HAYDEN VALLEY

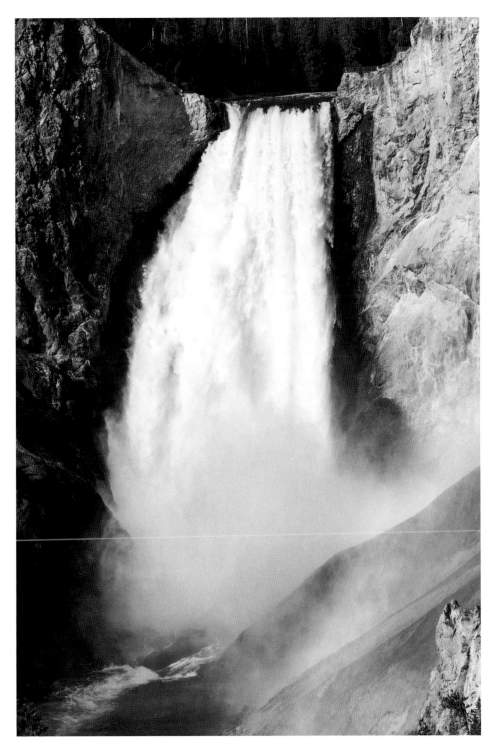

LOWER FALLS

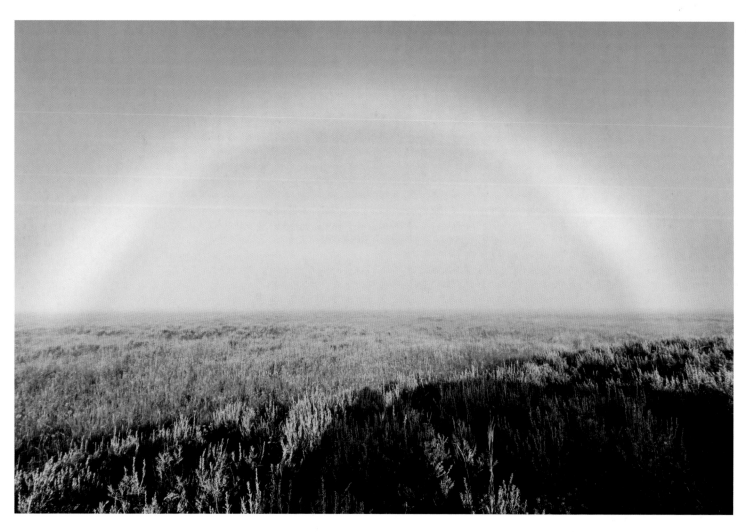

FOGBOW IN HAYDEN VALLEY

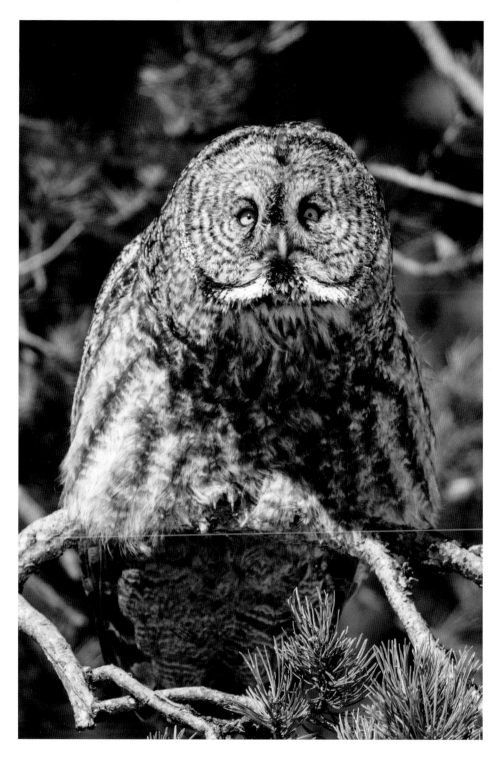

GREAT GRAY OWL

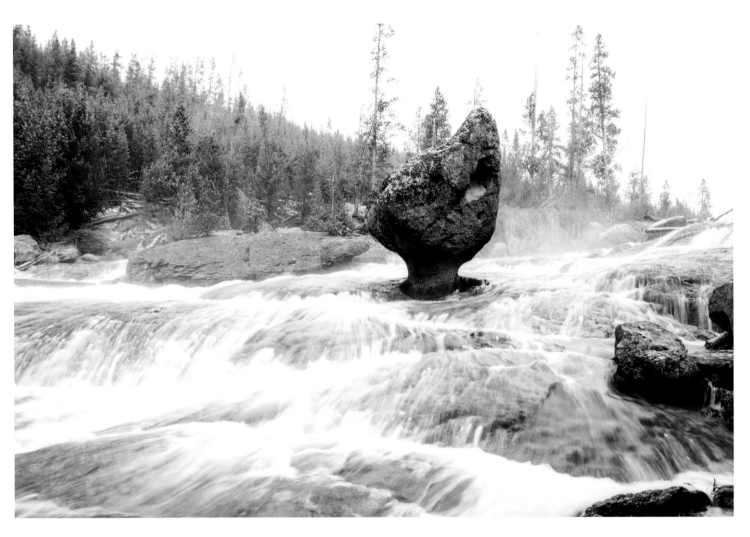

BALANCED ROCK, GIBBON RIVER

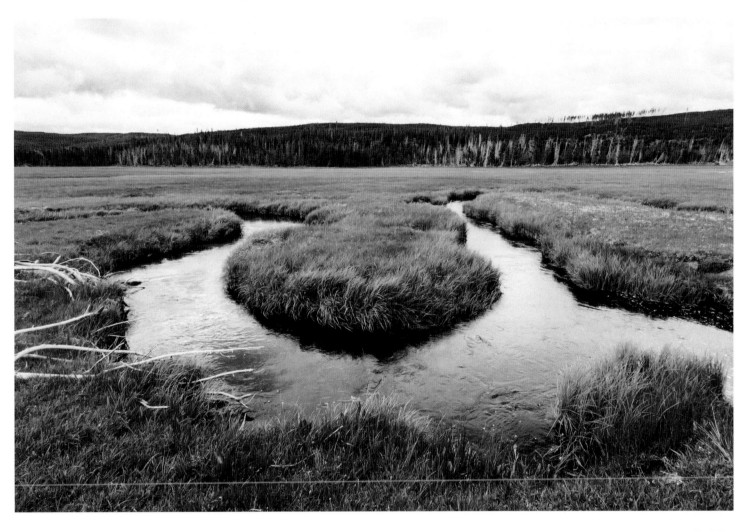

SENTINEL CREEK

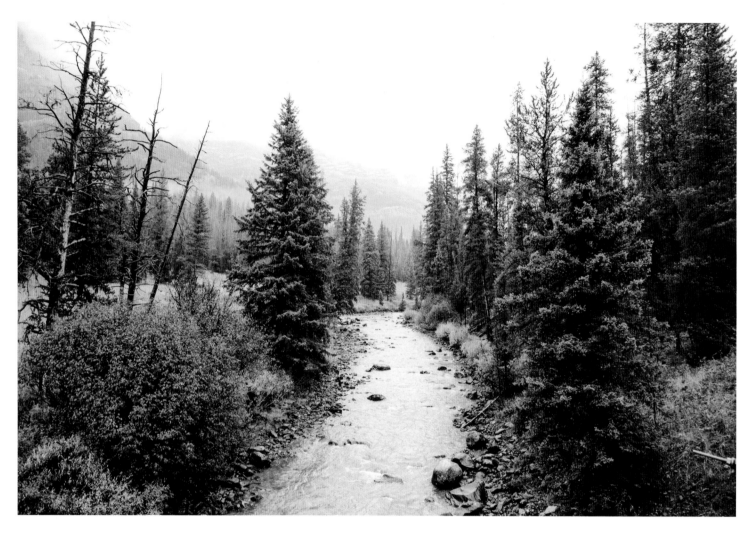

SODA BUTTE CREEK

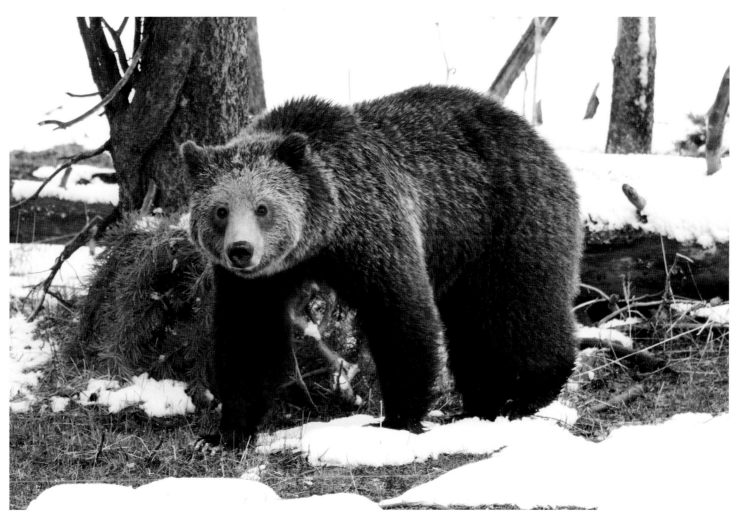

GRIZZLY BEAR

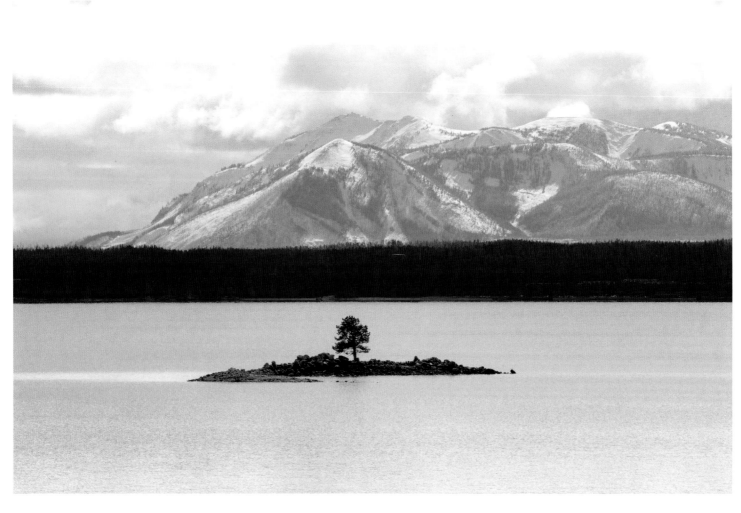

CARRINGTON ISLAND, YELLOWSTONE LAKE

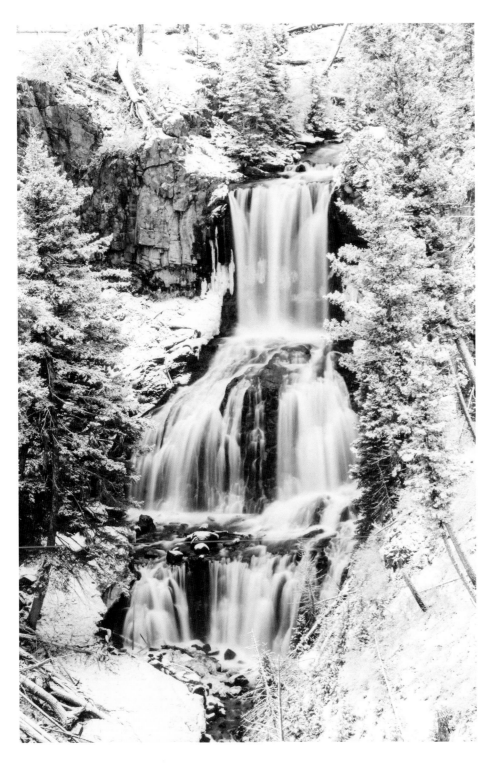

UNDINE FALLS

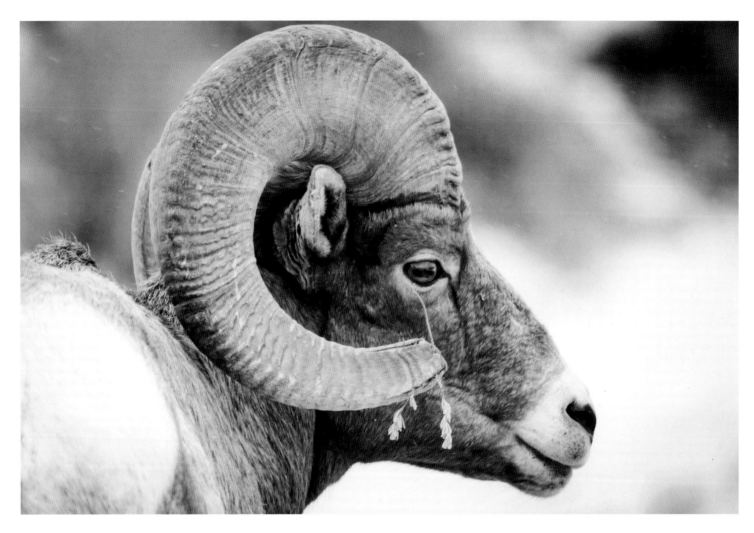

BIGHORN SHEEP RAM

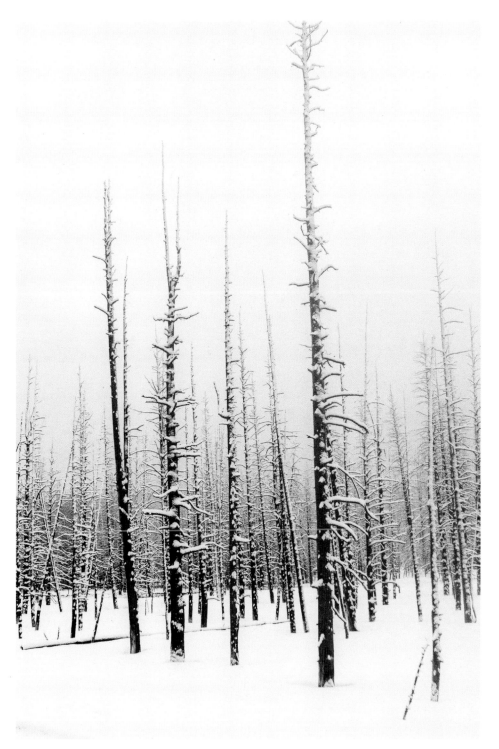

WINTER IN LOWER
GEYSER BASIN

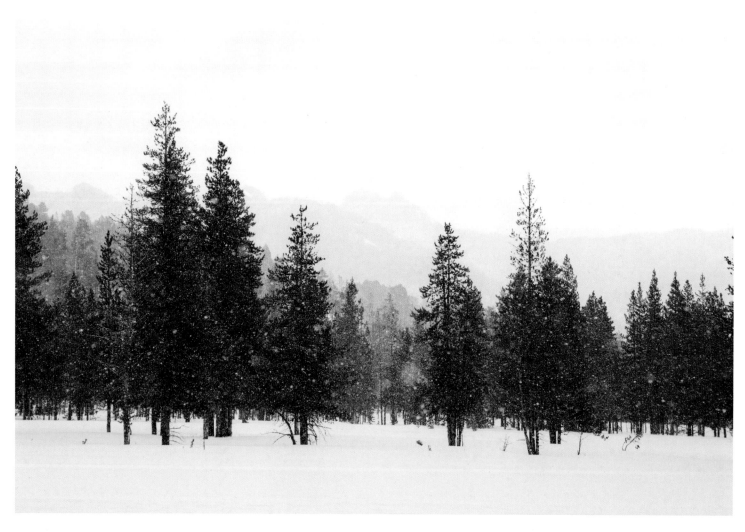

WINTER AT ROUND PRAIRIE

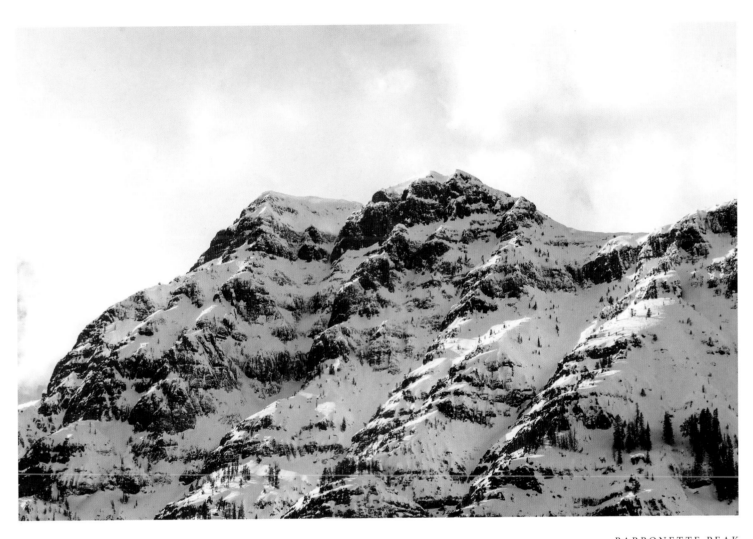

BARRONETTE PEAK
FOLLOWING PAGES: POND
NEAR SLOUGH CREEK

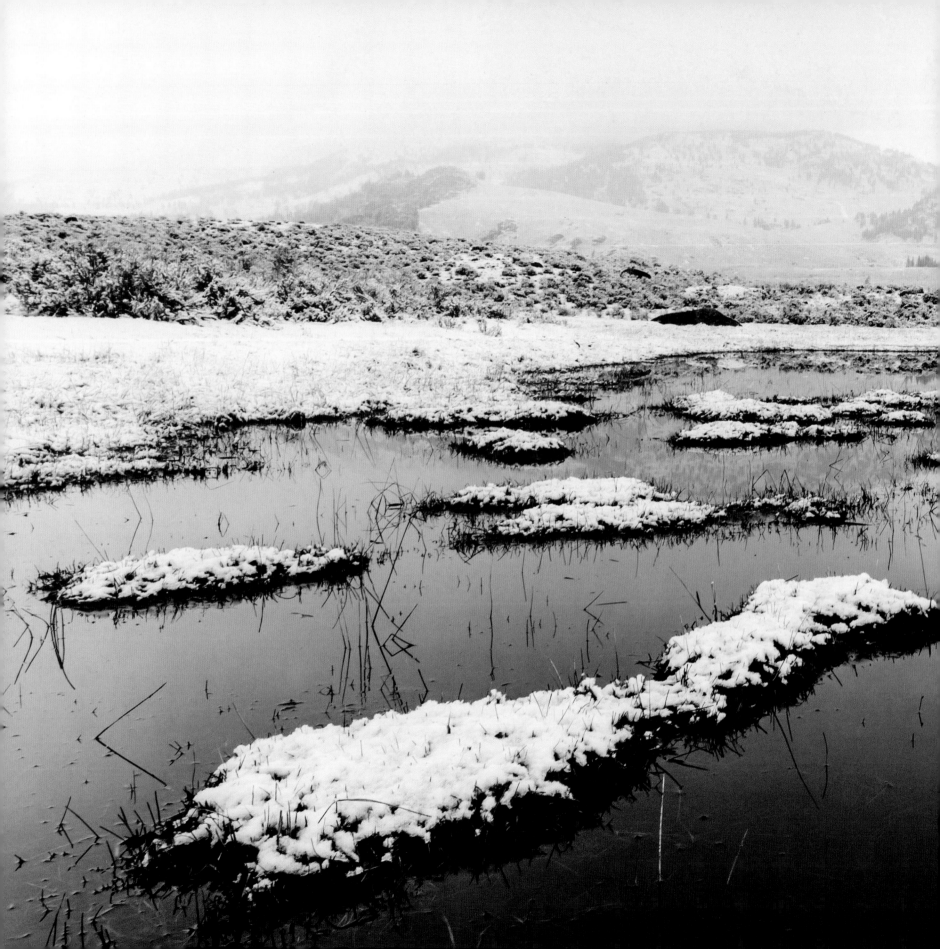

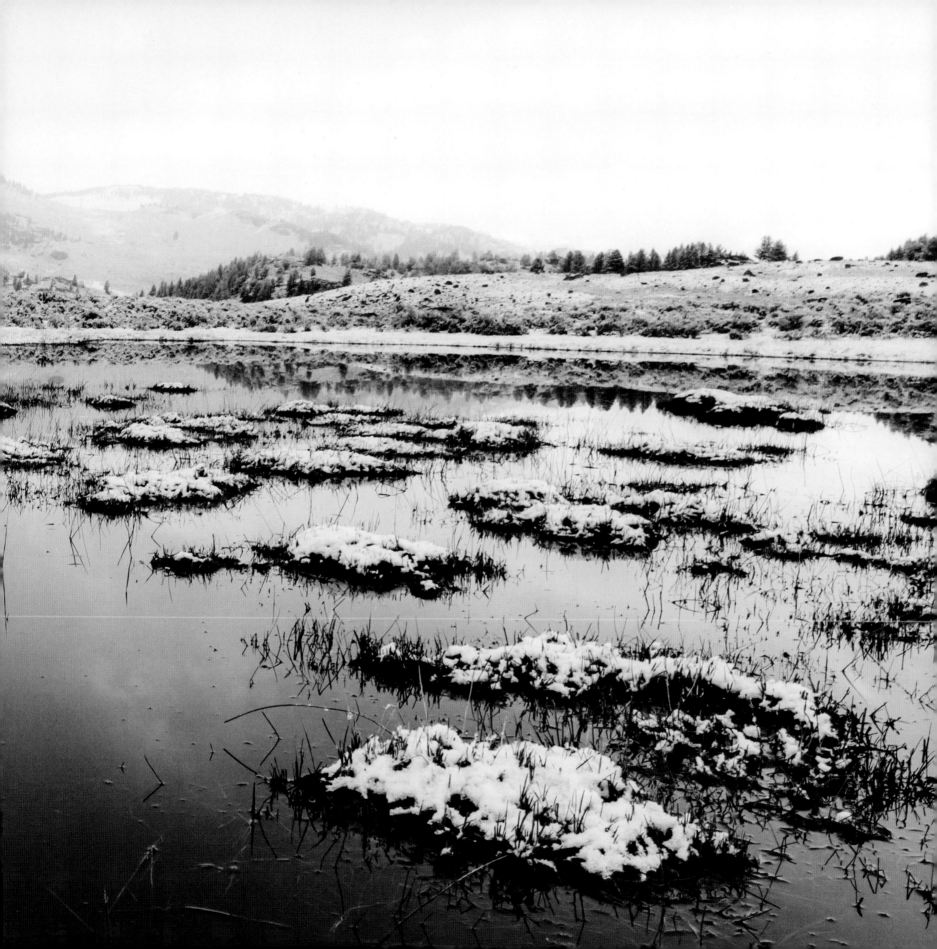

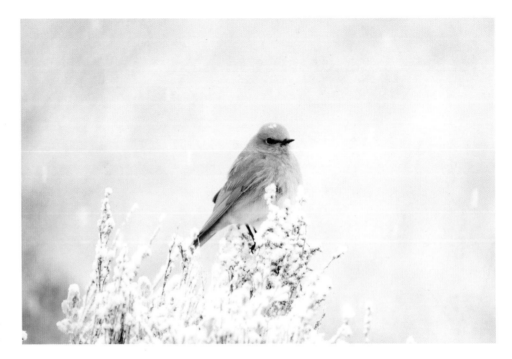

MOUNTAIN
BLUEBIRD

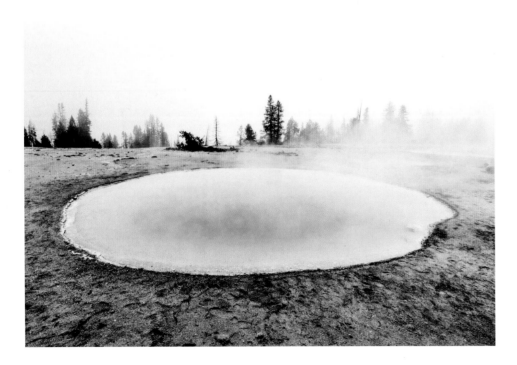

BLUE FUNNEL SPRING,
WEST THUMB GEYSER BASIN

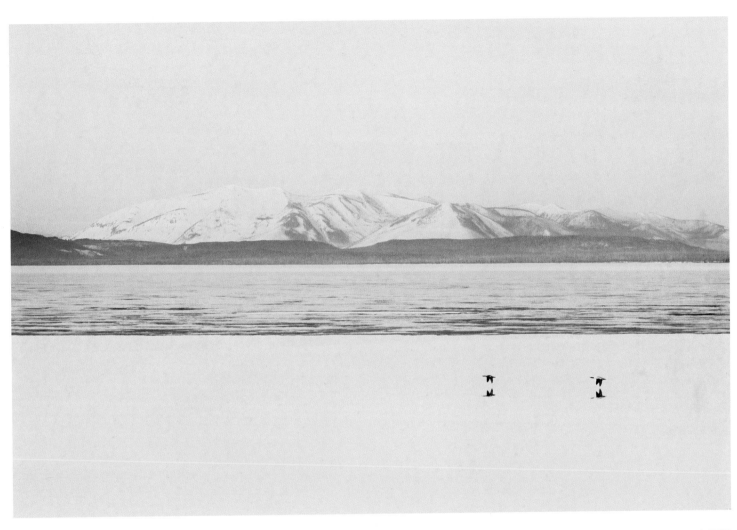

COMMON MERGANSERS FLYING OVER
PARTIALLY FROZEN YELLOWSTONE LAKE

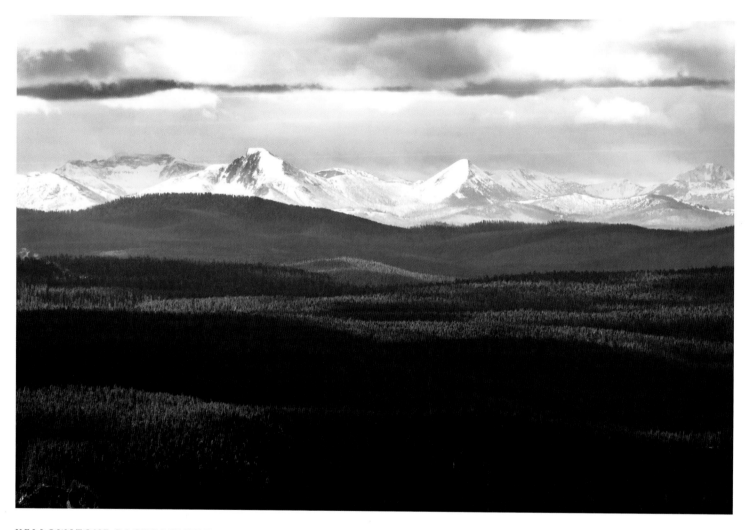

YELLOWSTONE BACKCOUNTRY
FROM THE WASHBURN RANGE

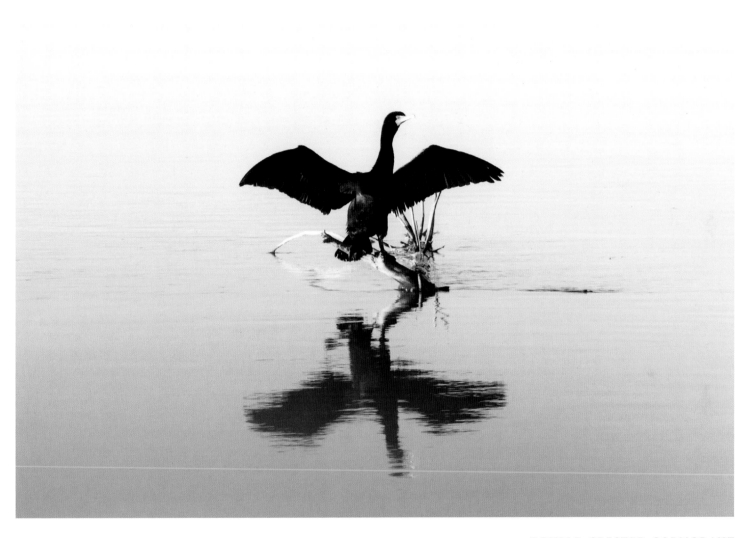

DOUBLE-CRESTED CORMORANT

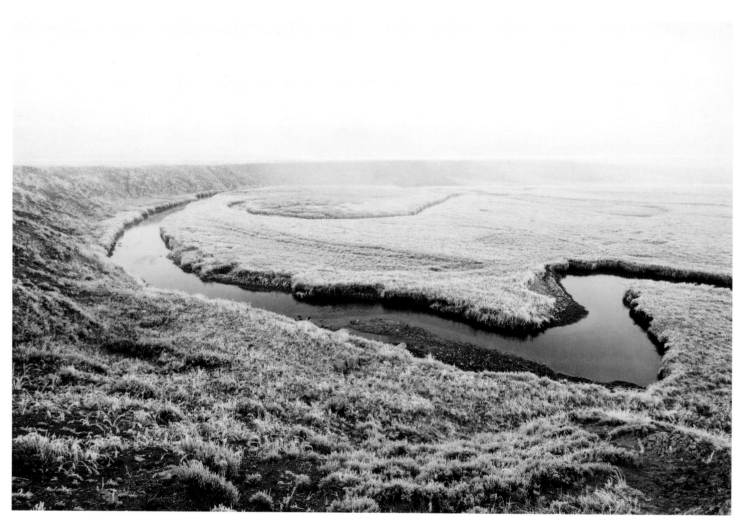

FROSTY MORNING IN HAYDEN VALLEY

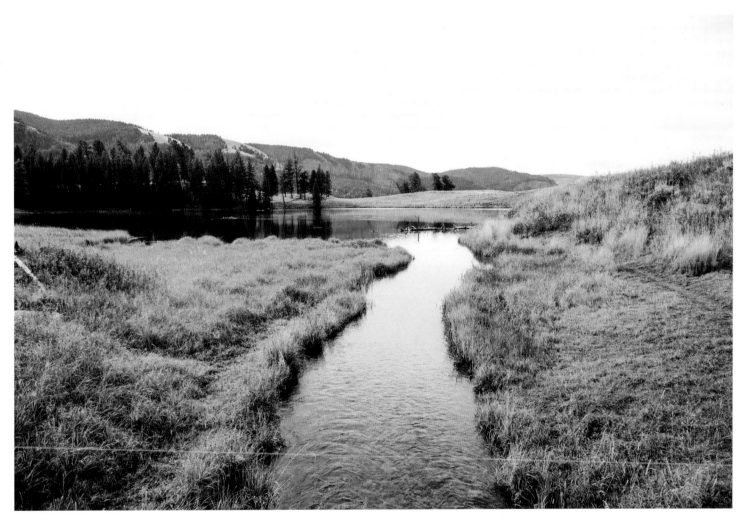

TROUT LAKE

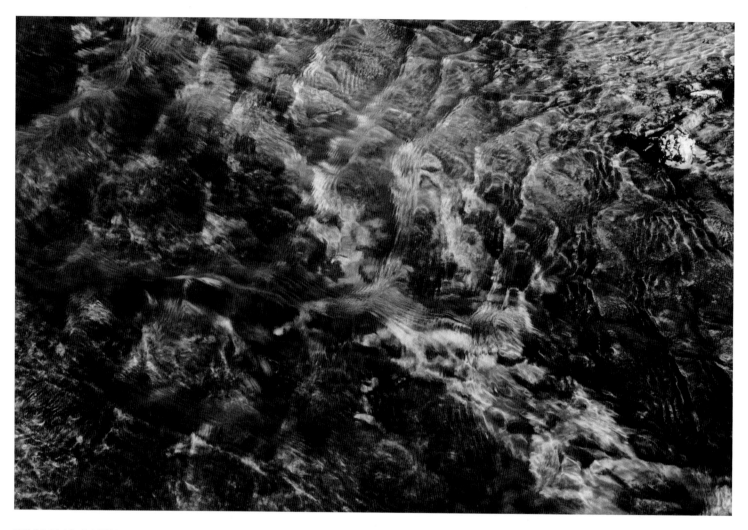

THERMAL PATTERN IN NORRIS GEYSER BASIN

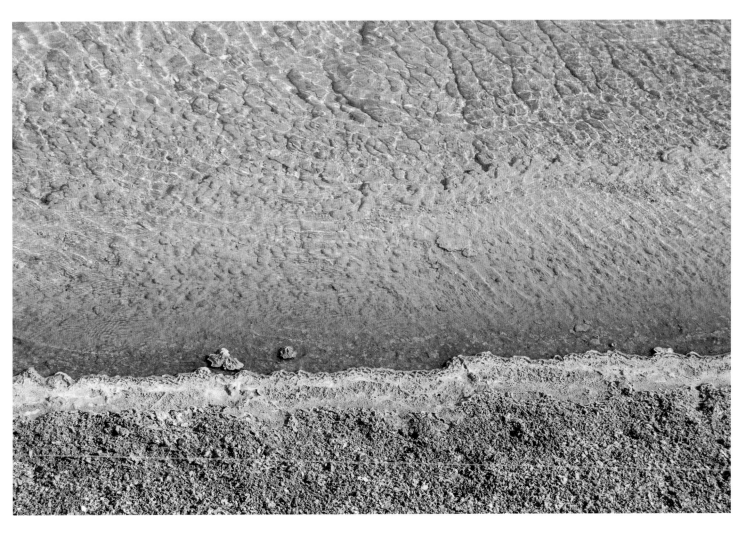

SUNSET LAKE, BLACK SAND BASIN

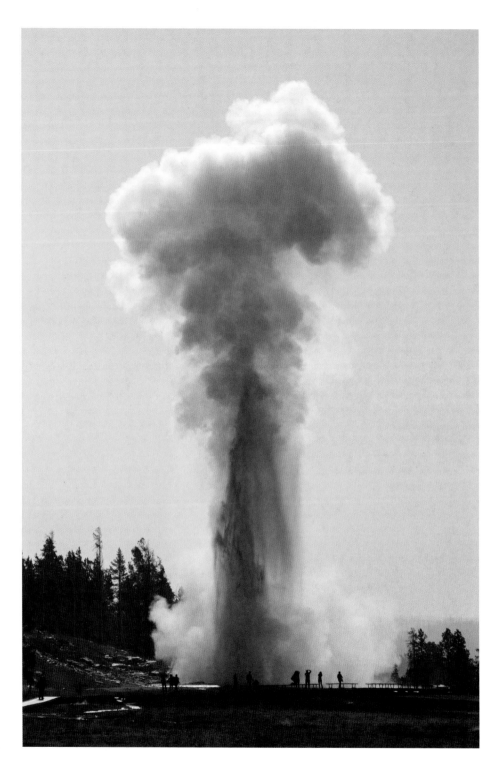

GRAND GEYSER

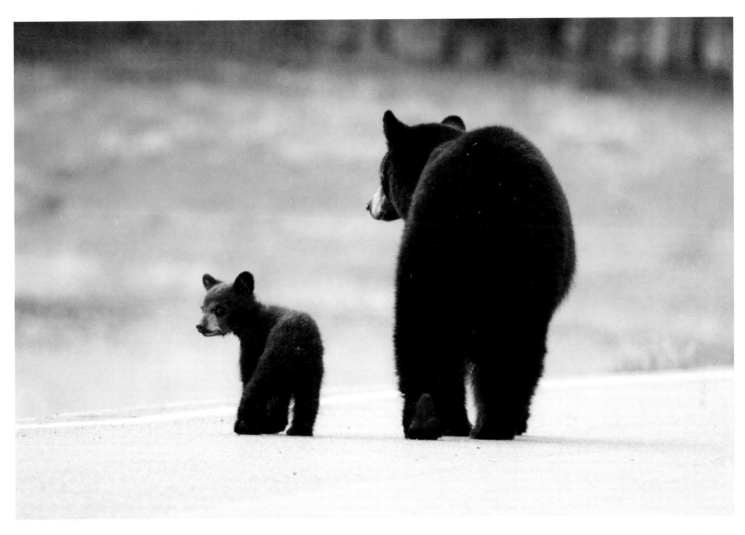

BLACK BEAR SOW AND CUB
FOLLOWING PAGES: SUMMER
IN LAMAR VALLEY

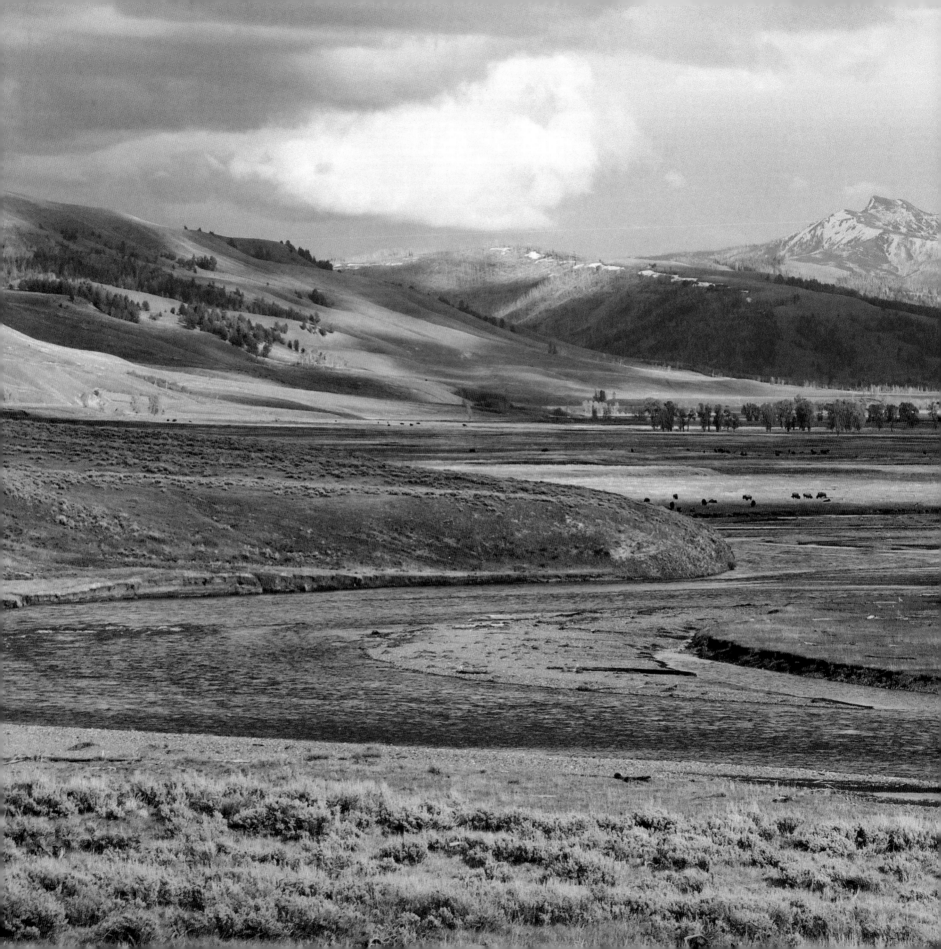

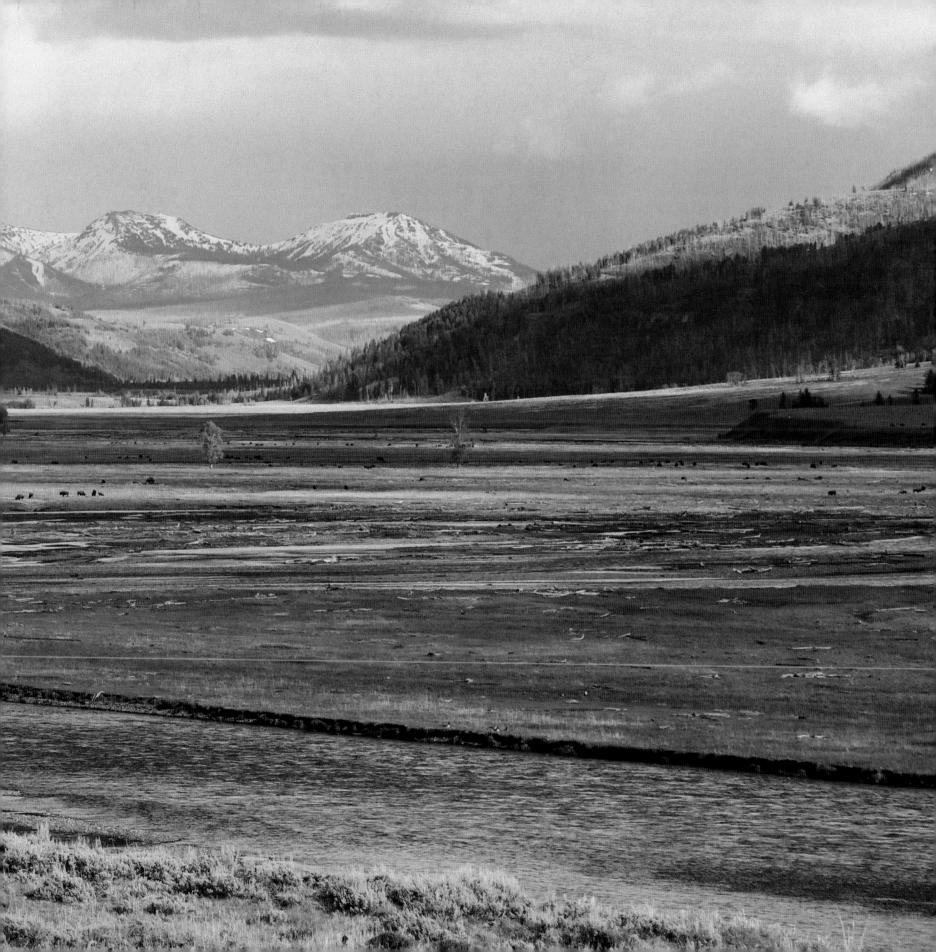

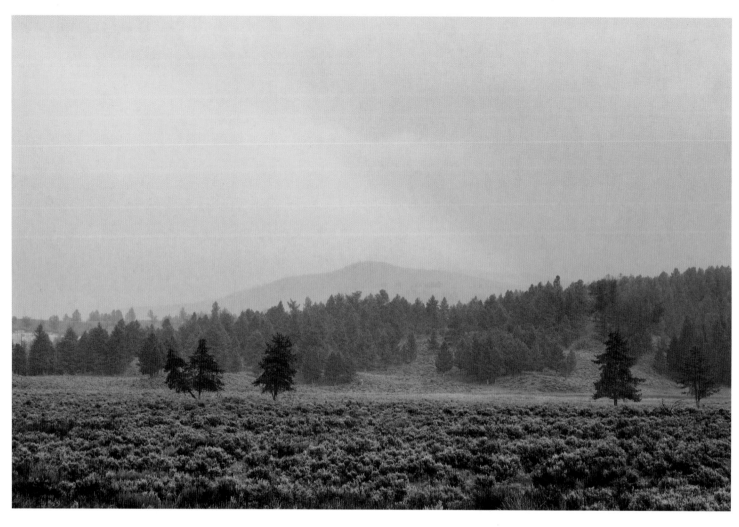

RAINBOW AT TOWER JUNCTION

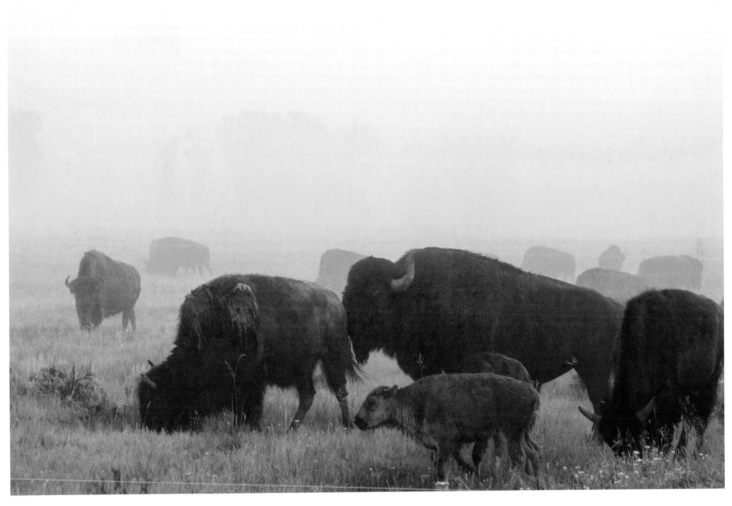

BISON IN HAYDEN VALLEY

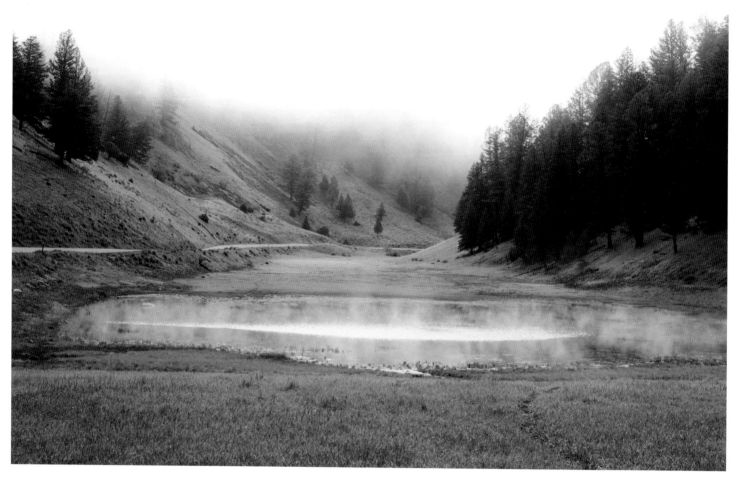

PHANTOM LAKE

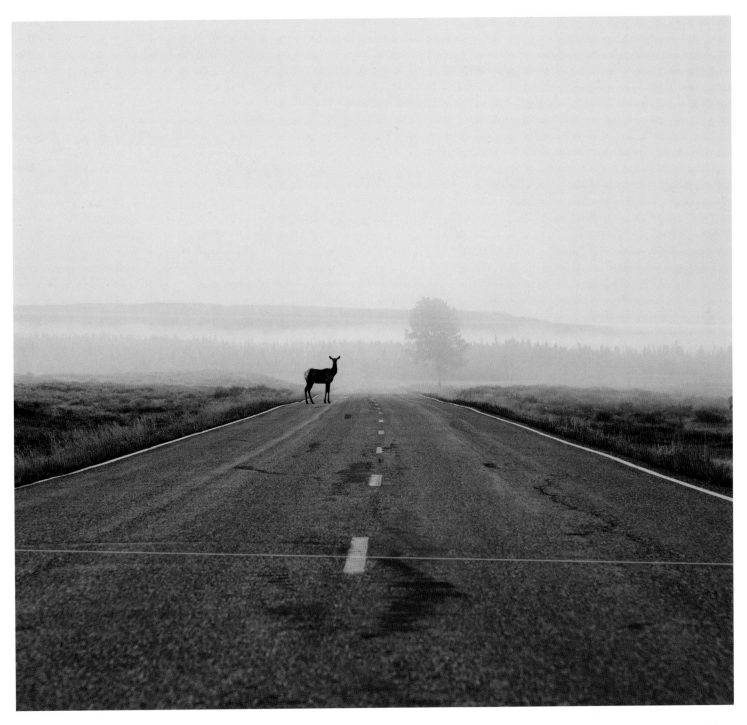

COW ELK AT SWAN LAKE FLATS

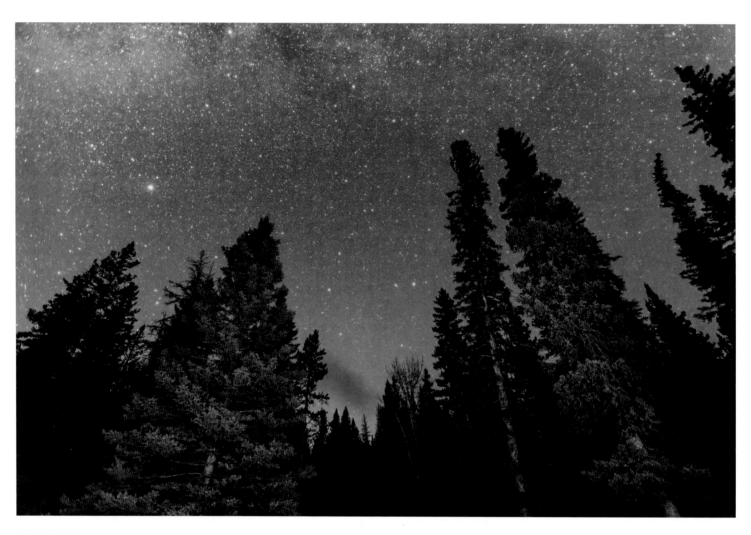

NIGHT SKY NEAR SODA BUTTE CREEK

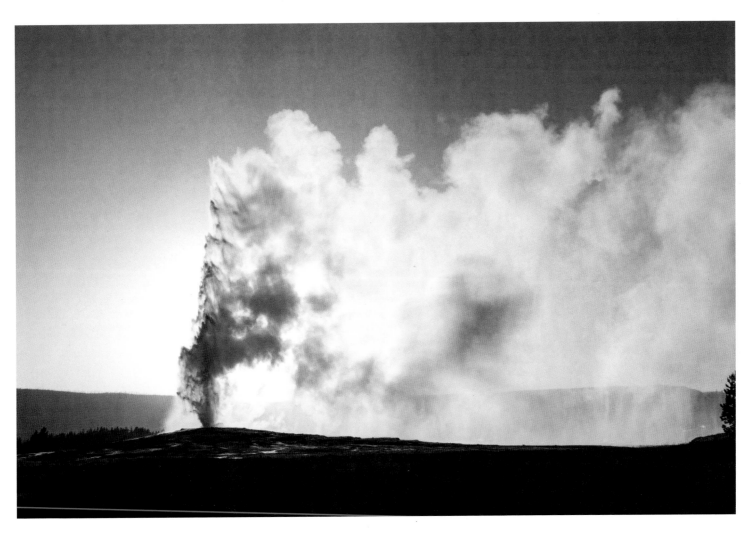

OLD FAITHFUL

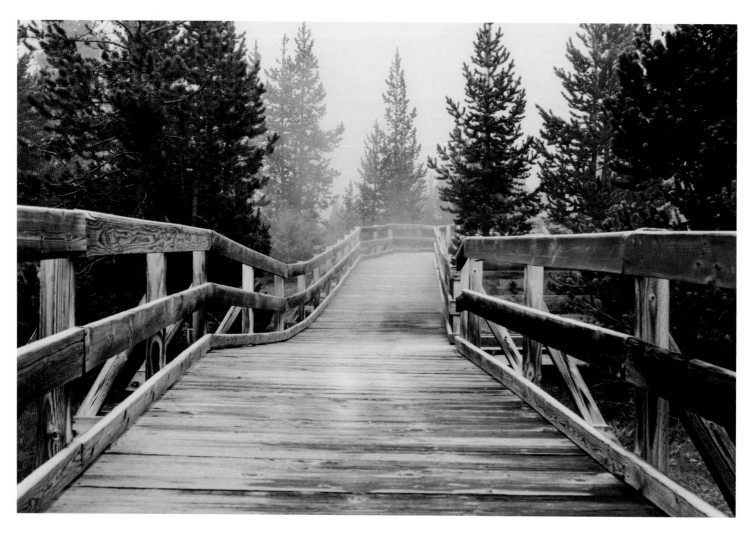

BOARDWALK, WEST THUMB GEYSER BASIN

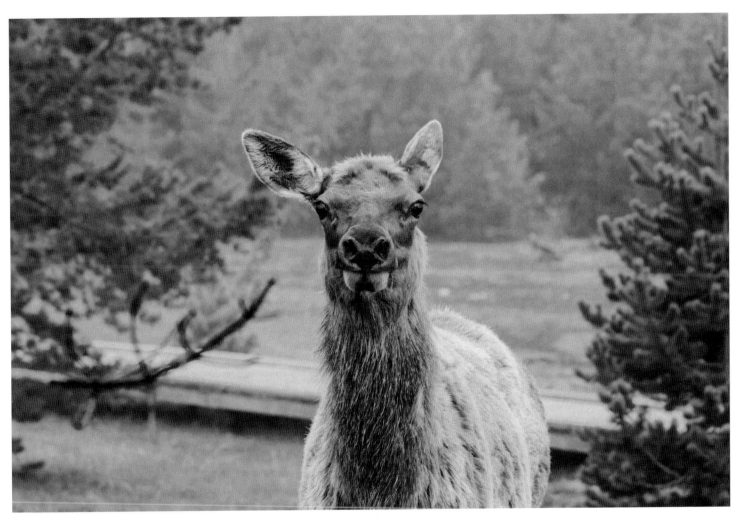

COW ELK AT WEST THUMB GEYSER BASIN

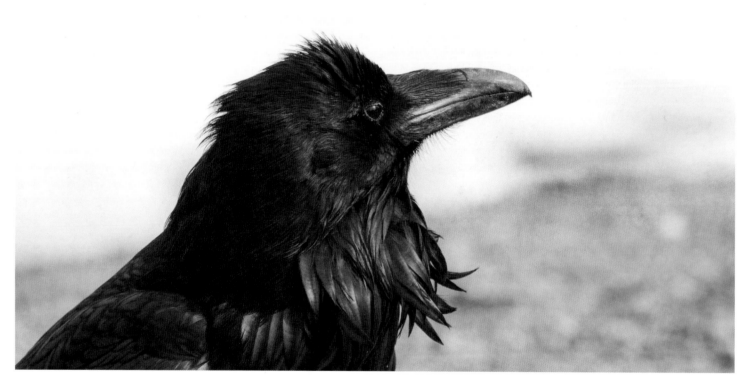

COMMON RAVEN

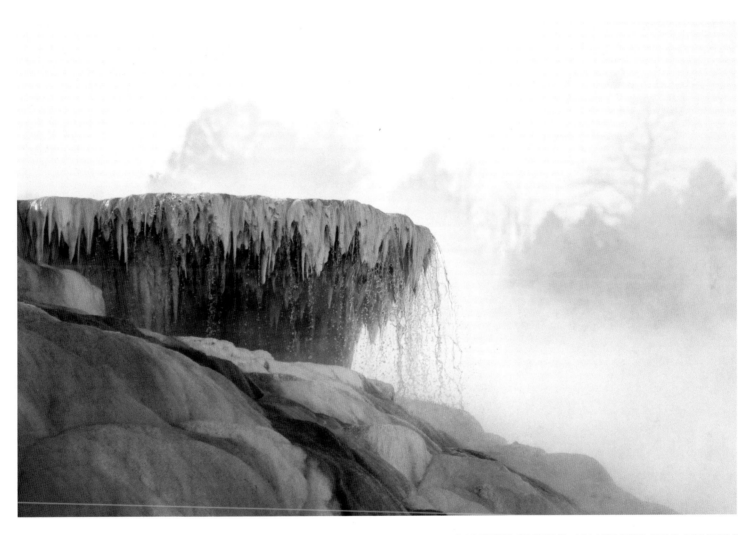

PALETTE SPRING, MAMMOTH HOT SPRINGS

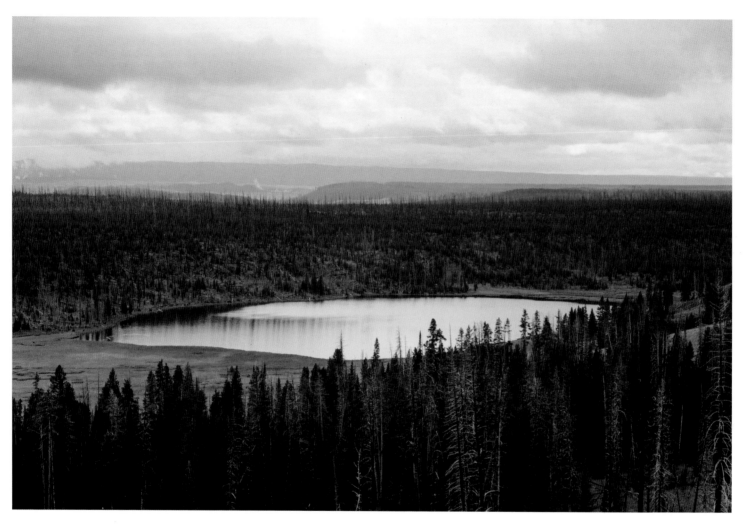

CASCADE LAKE

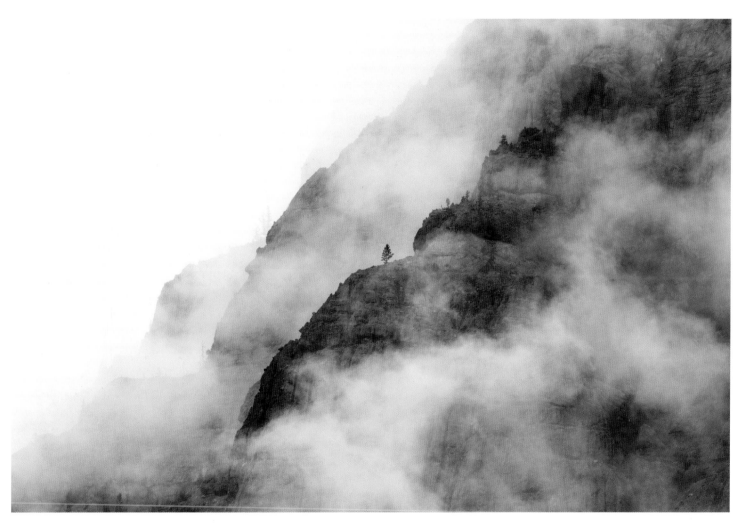

BARRONETTE PEAK

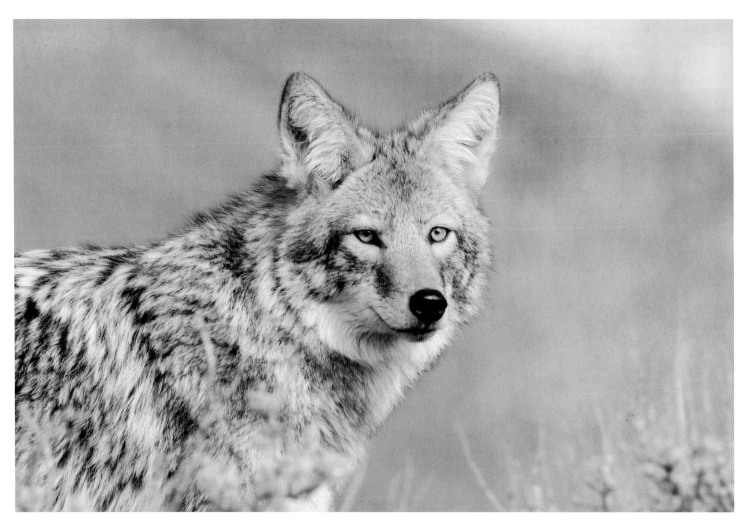

COYOTE

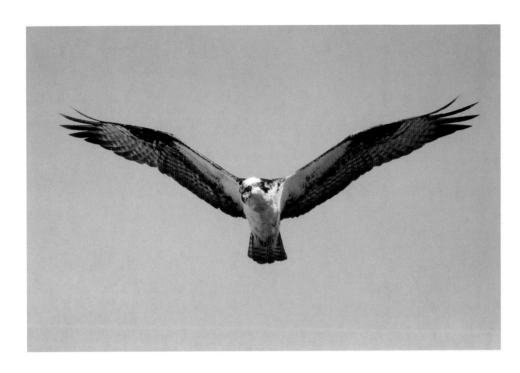

OSPREY ABOVE THE
FIREHOLE RIVER

WILLETS ON THE SHORE OF
YELLOWSTONE LAKE

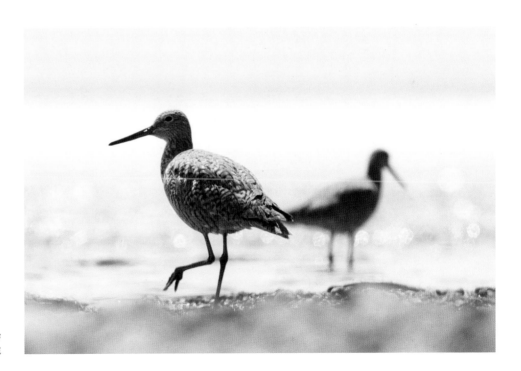

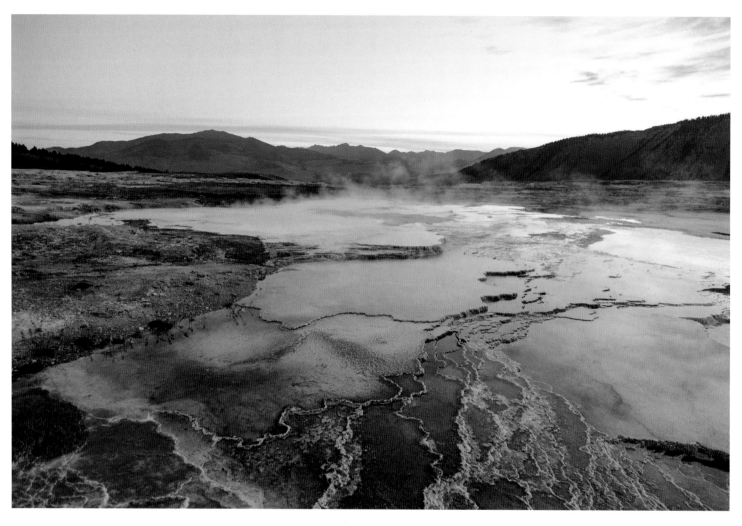

CANARY SPRING,
MAMMOTH HOT SPRINGS

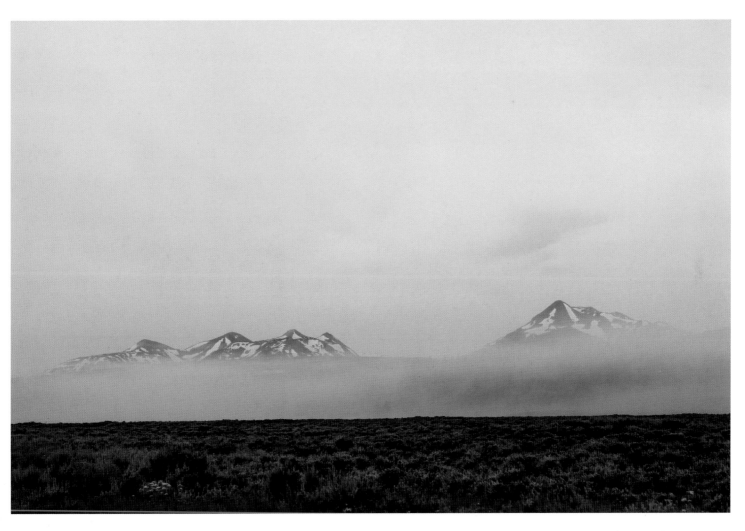

ANTLER PEAK (RIGHT) AND THE
GALLATIN RANGE, SWAN LAKE FLATS

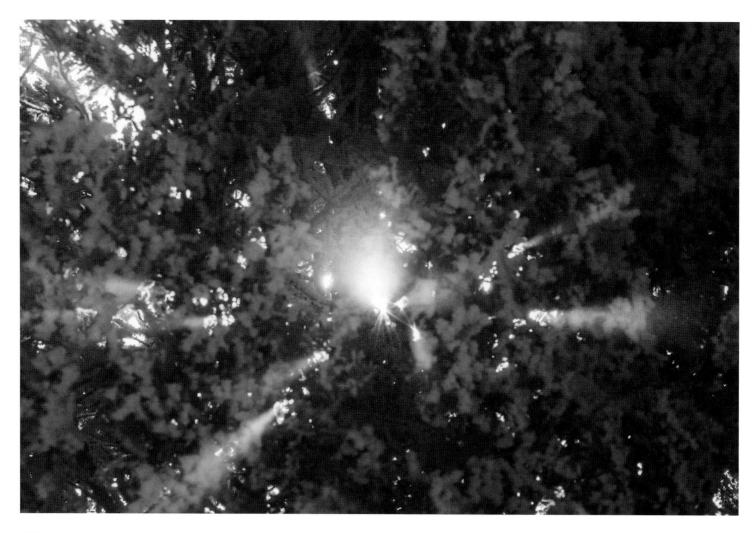

SUNBURST THROUGH THE TREES
AT MAMMOTH HOT SPRINGS

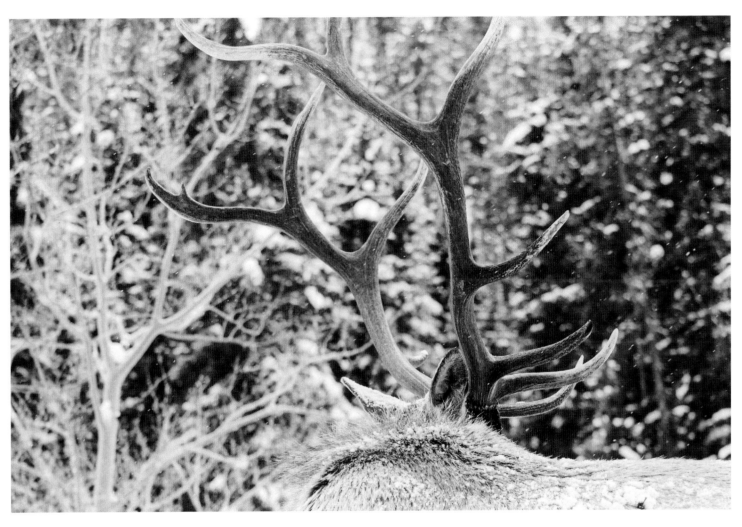

BULL ELK IN WINTER

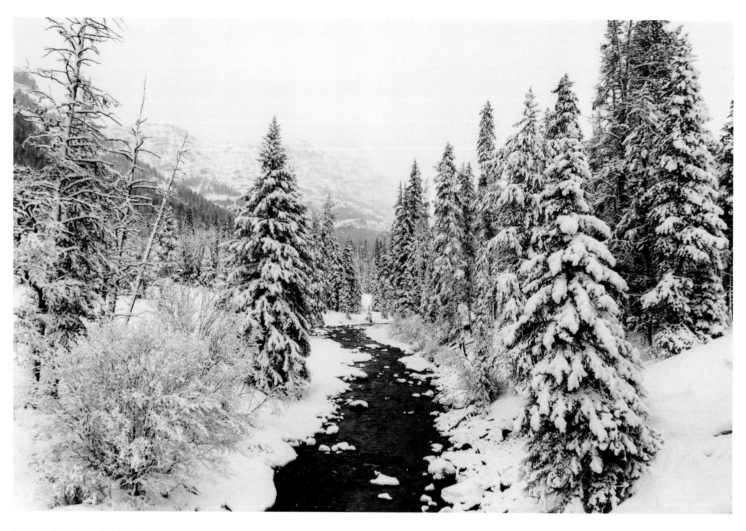

SODA BUTTE CREEK

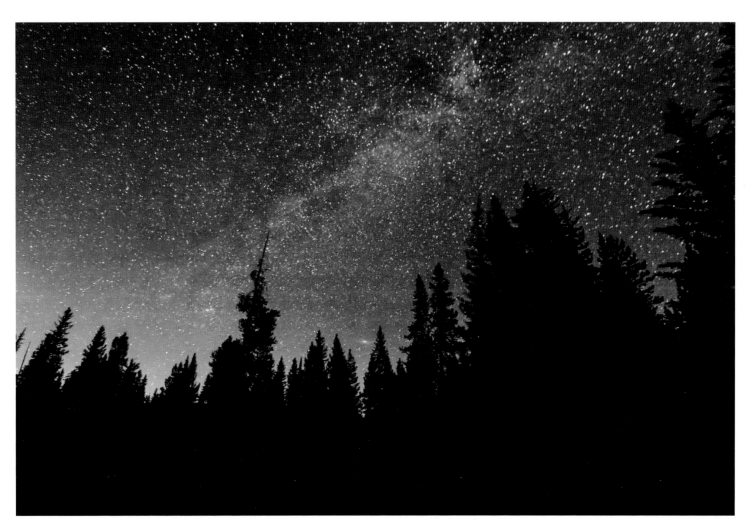

YELLOWSTONE NIGHT SKY

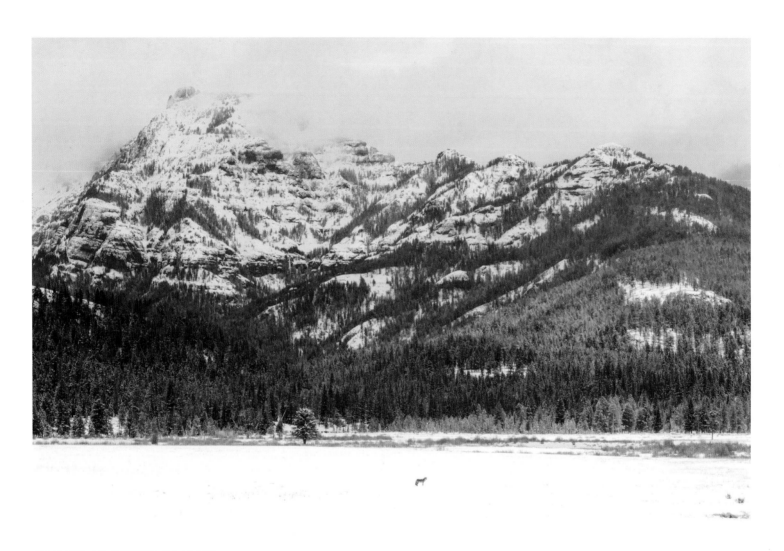

COYOTE AT ROUND PRAIRIE

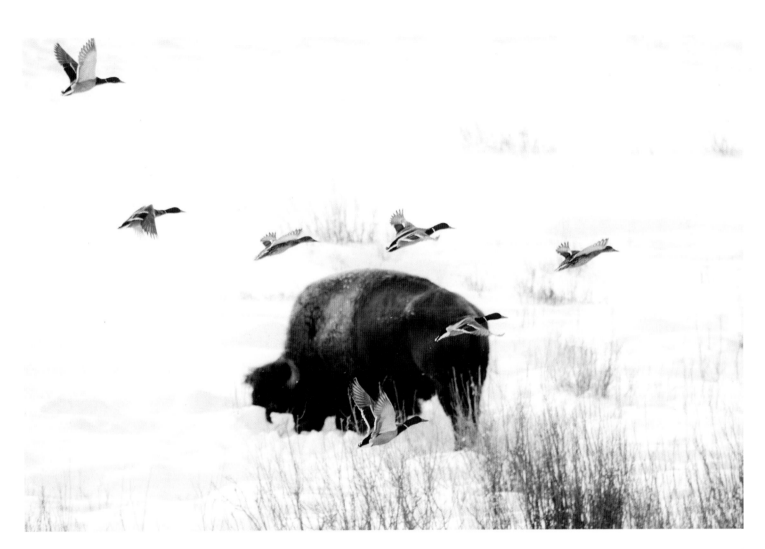

BISON AND MALLARDS

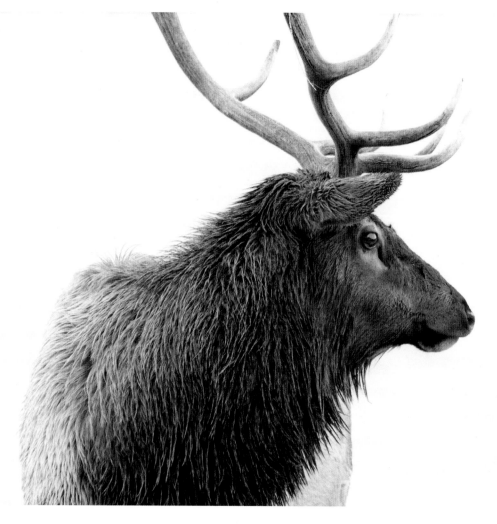

BULL ELK

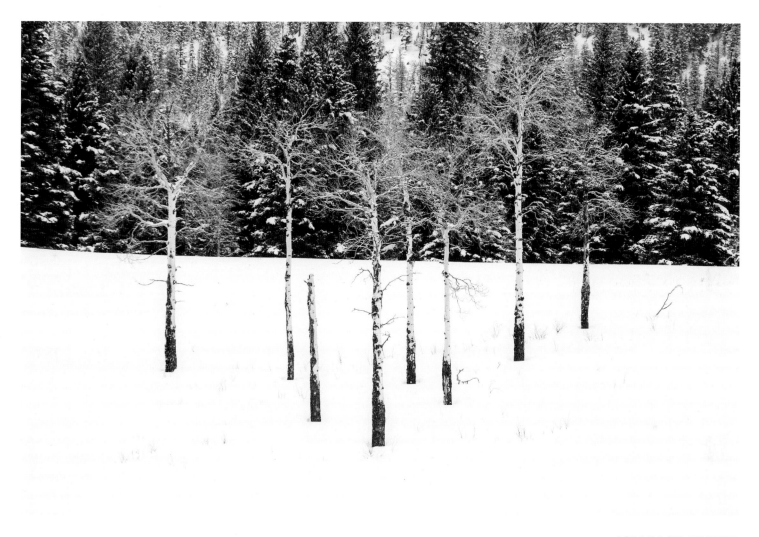

ASPENS IN WINTER
FOLLOWING PAGES: WINTER NEAR
THE NORTHEAST ENTRANCE

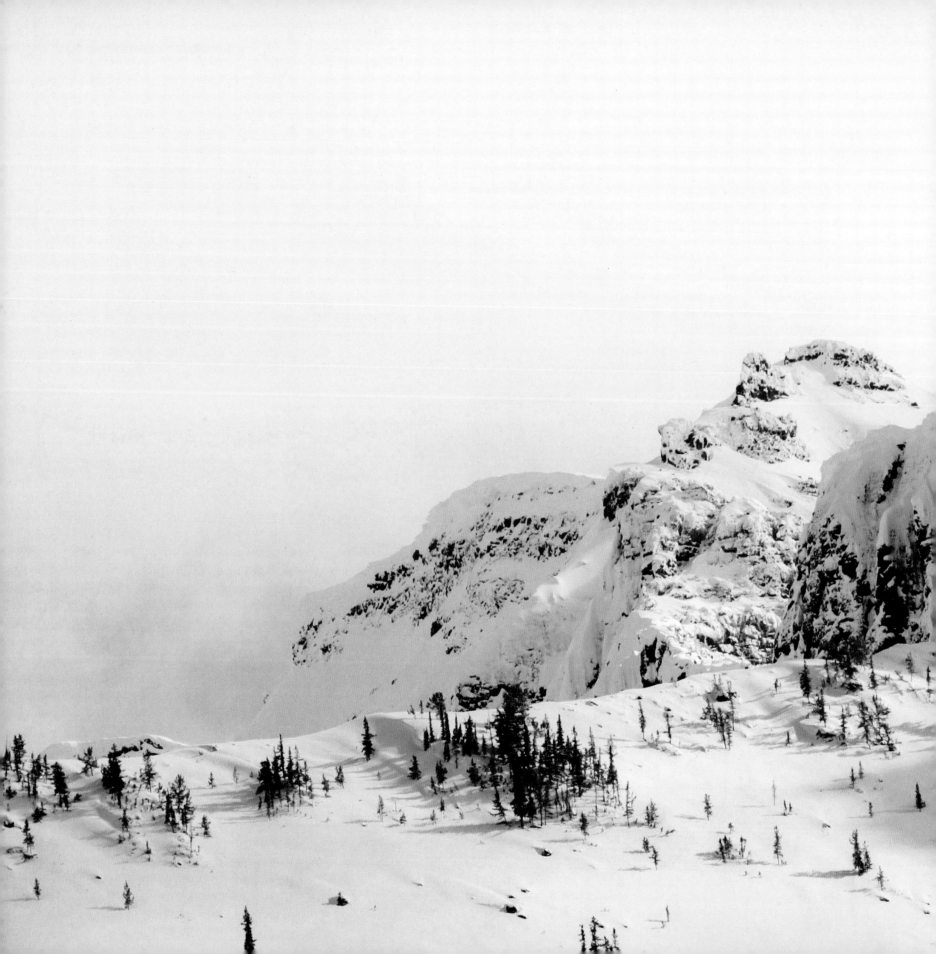

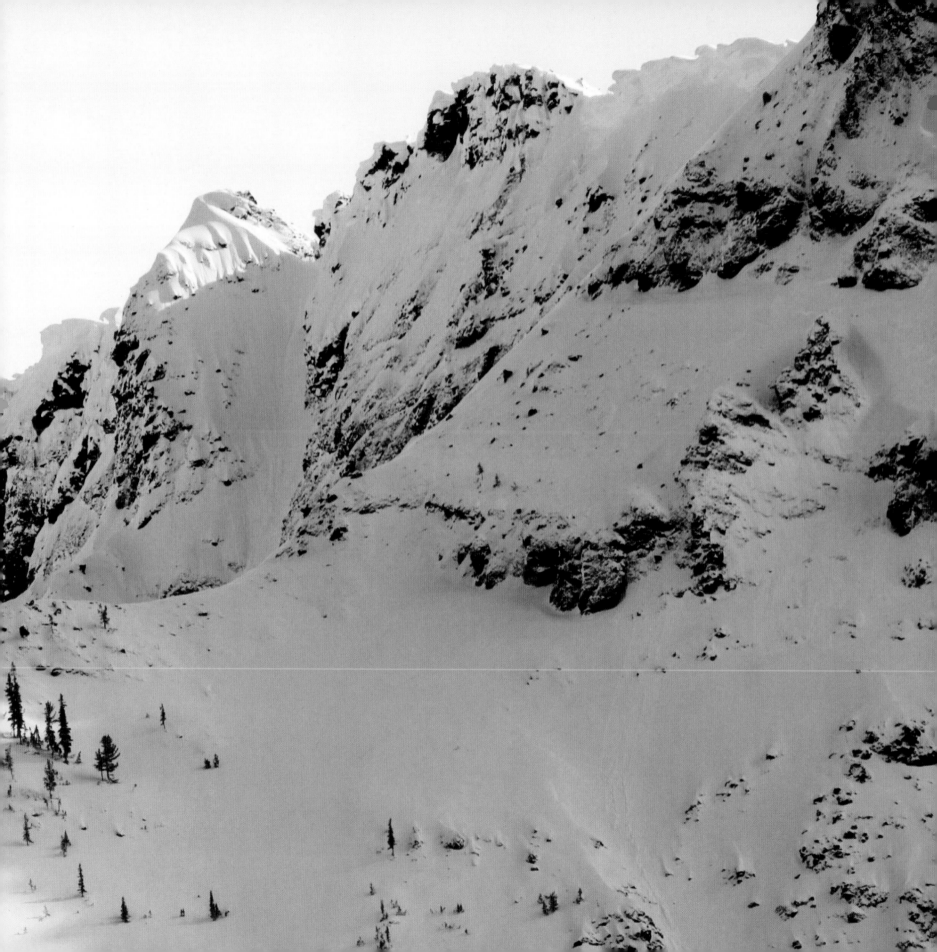

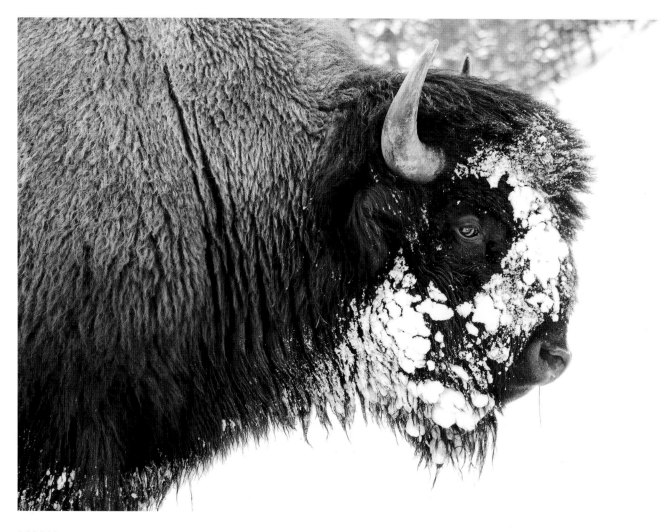

BISON

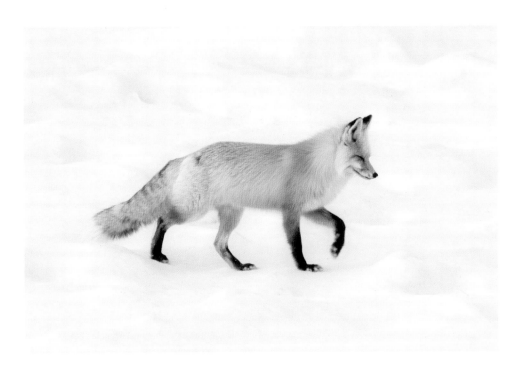

RED FOX

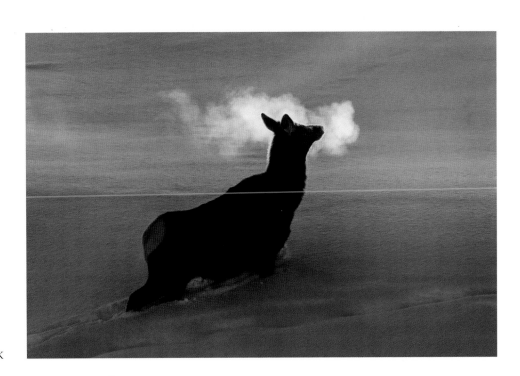

COW ELK

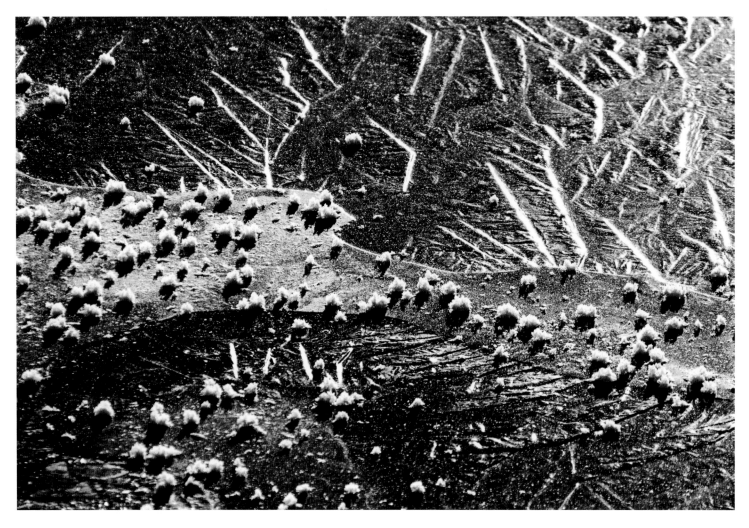

ICE PATTERN ON SODA BUTTE CREEK

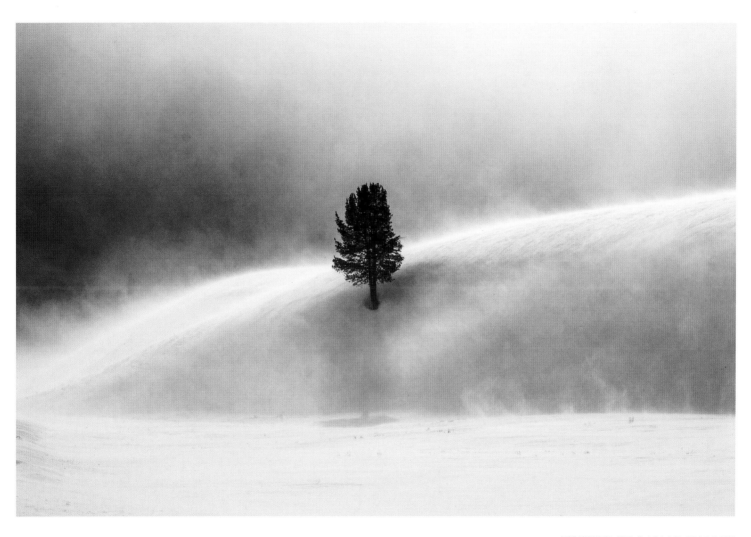

WINTER IN LAMAR VALLEY

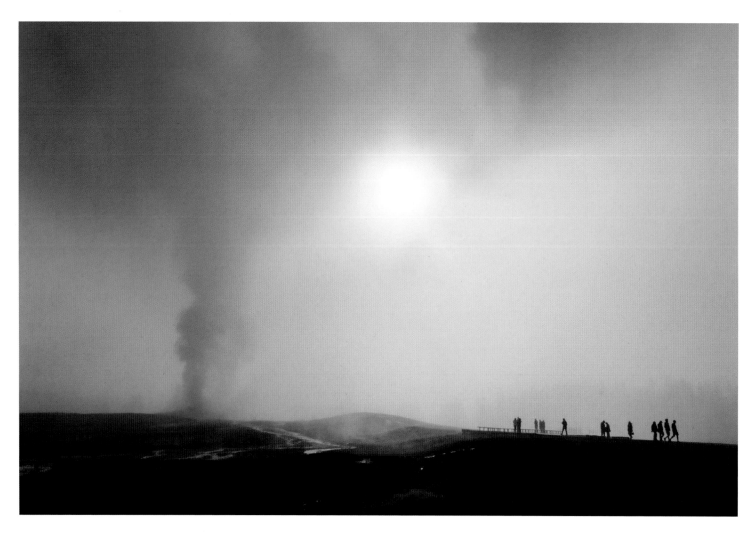

OLD FAITHFUL

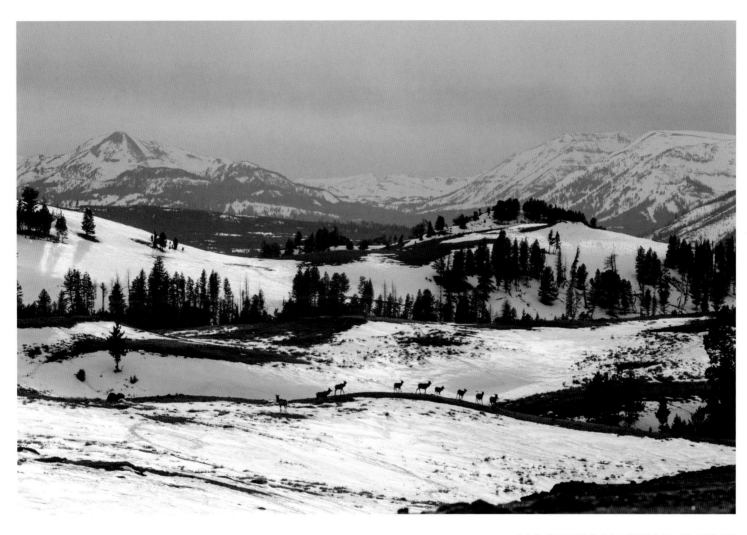

ELK ON THE BLACKTAIL PLATEAU

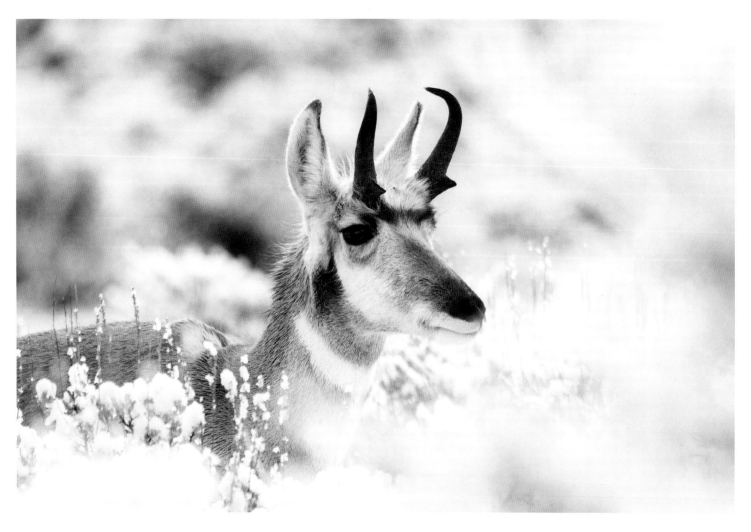

PRONGHORN

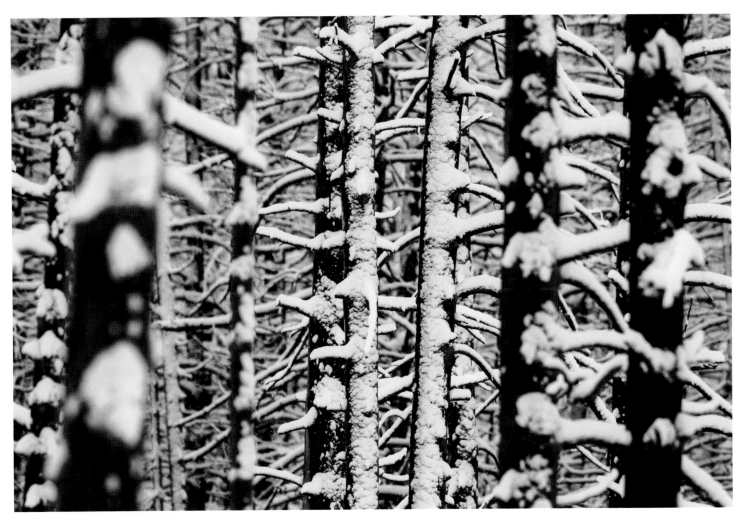

LODGEPOLE PINES

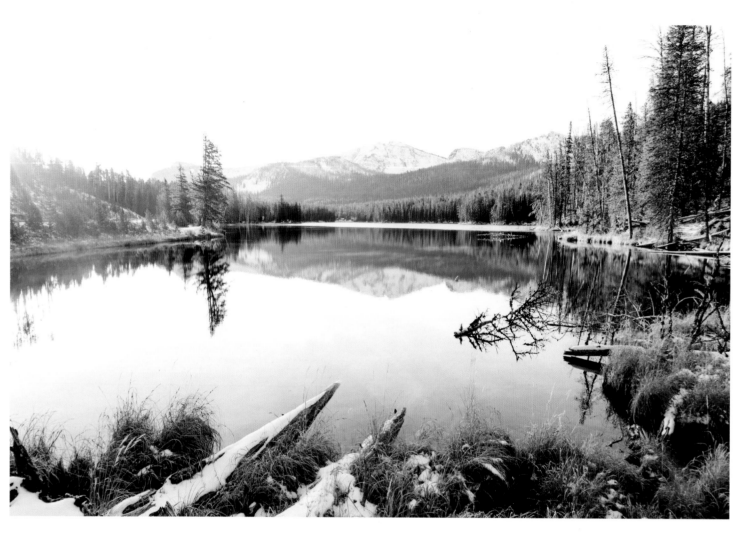

SYLVAN LAKE

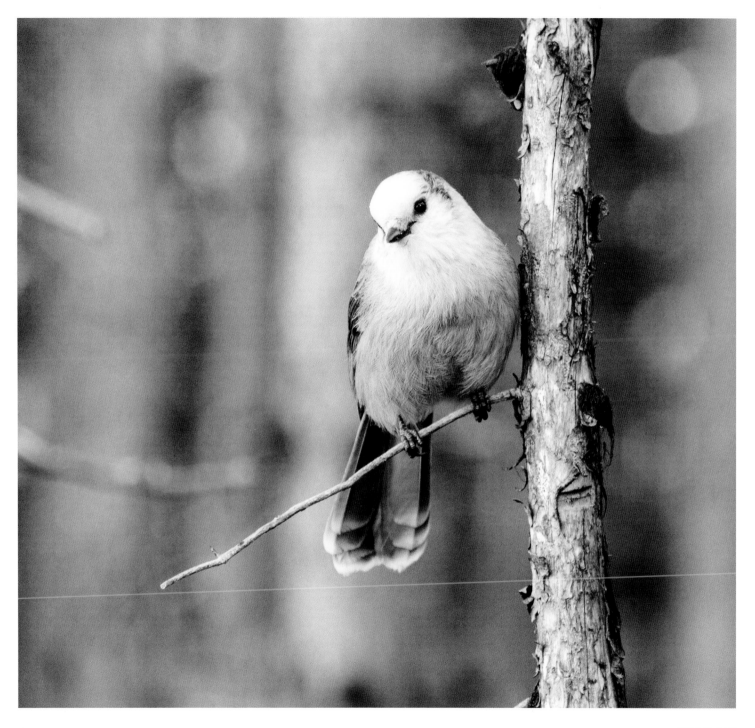

GRAY JAY

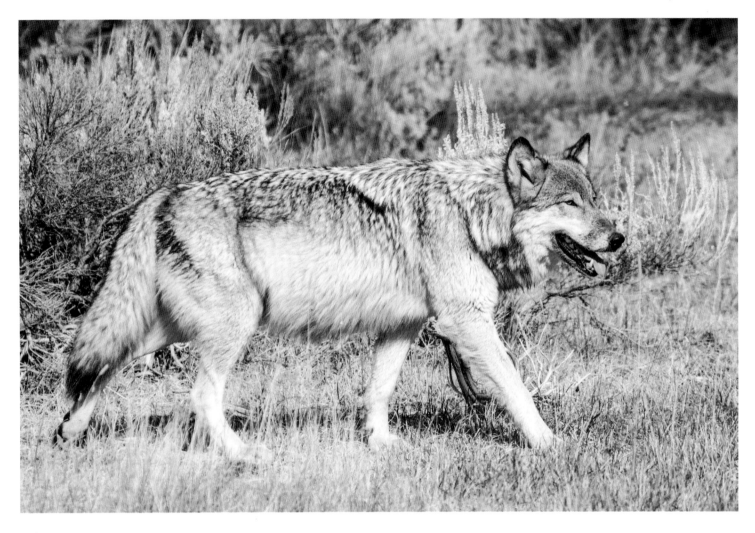

WOLF

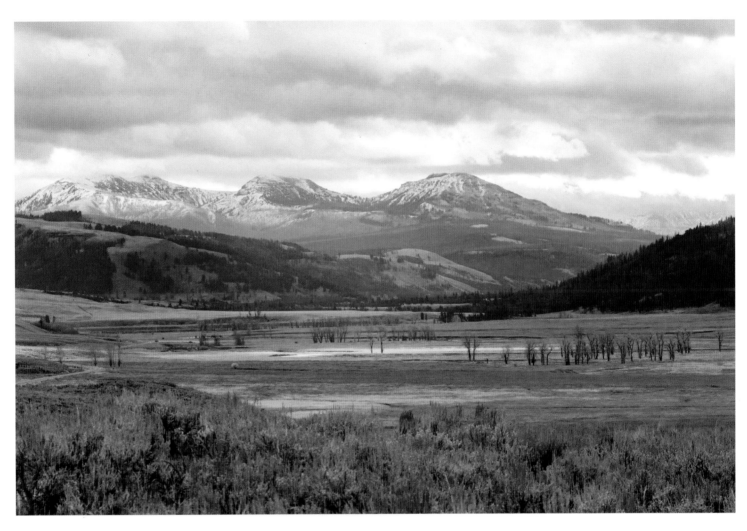

LAMAR VALLEY

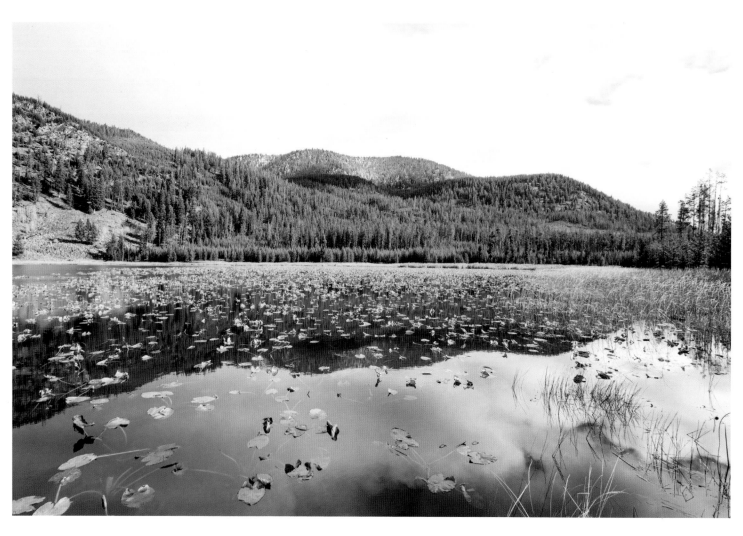

HARLEQUIN LAKE

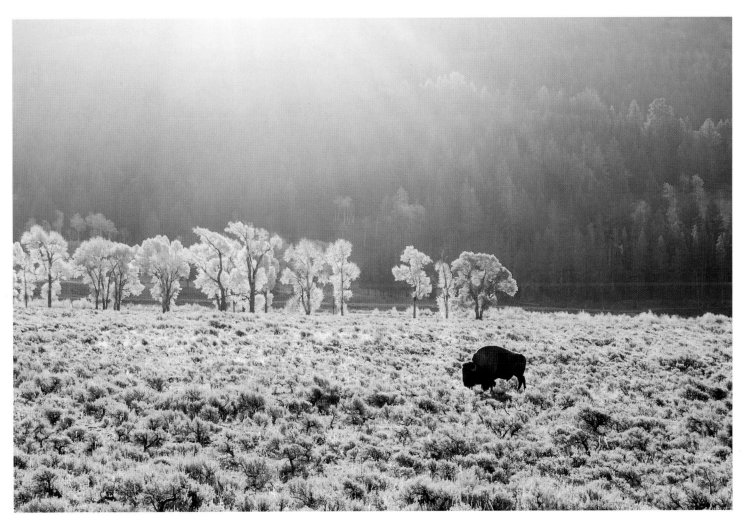

BISON IN LAMAR VALLEY

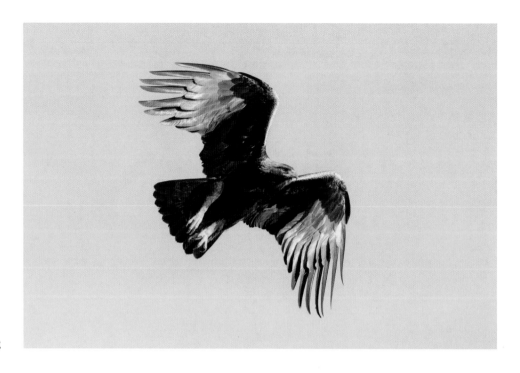

GOLDEN EAGLE

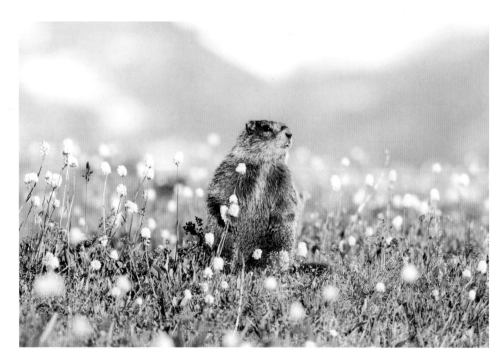

YELLOW-BELLIED
MARMOT

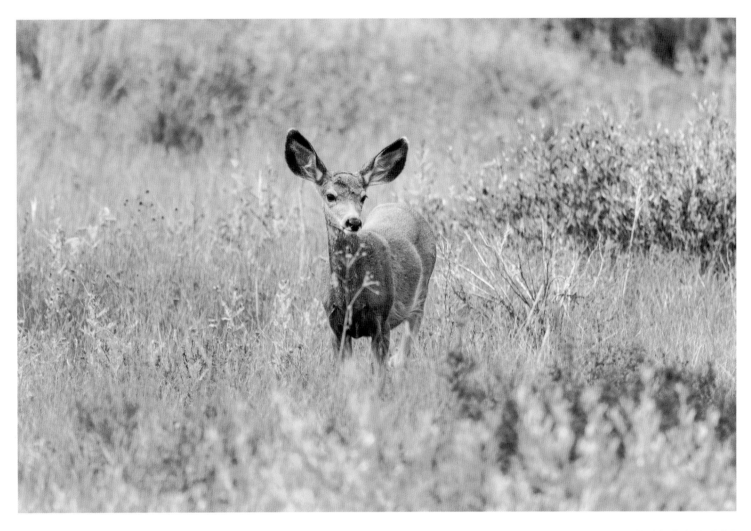

MULE DEER DOE

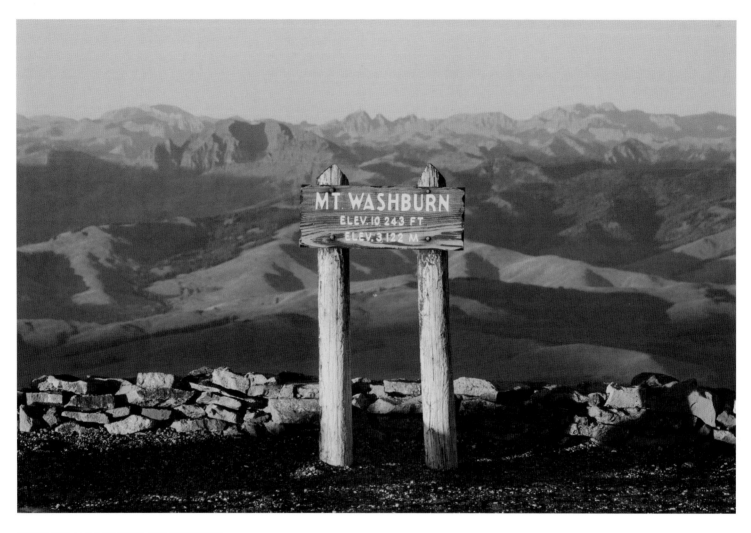

SUMMIT OF MOUNT WASHBURN

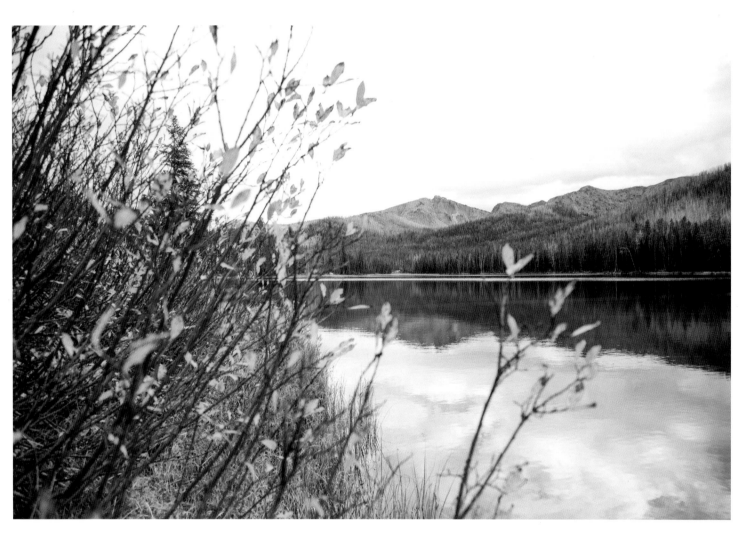

SYLVAN LAKE

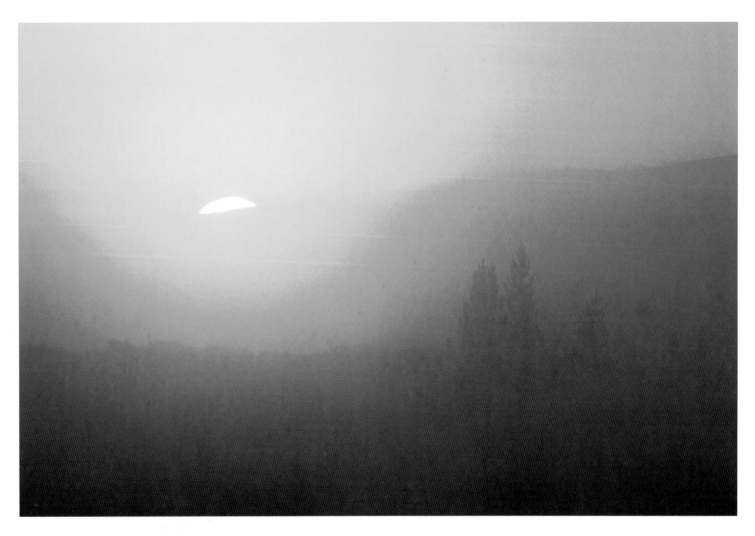

SUNRISE AT SWAN LAKE FLATS

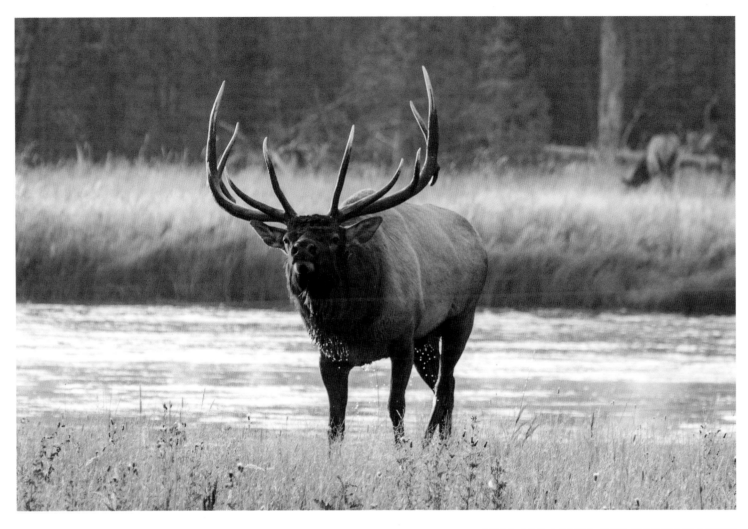

BULL ELK ALONG THE MADISON RIVER
FOLLOWING PAGES: YELLOWSTONE LAKE

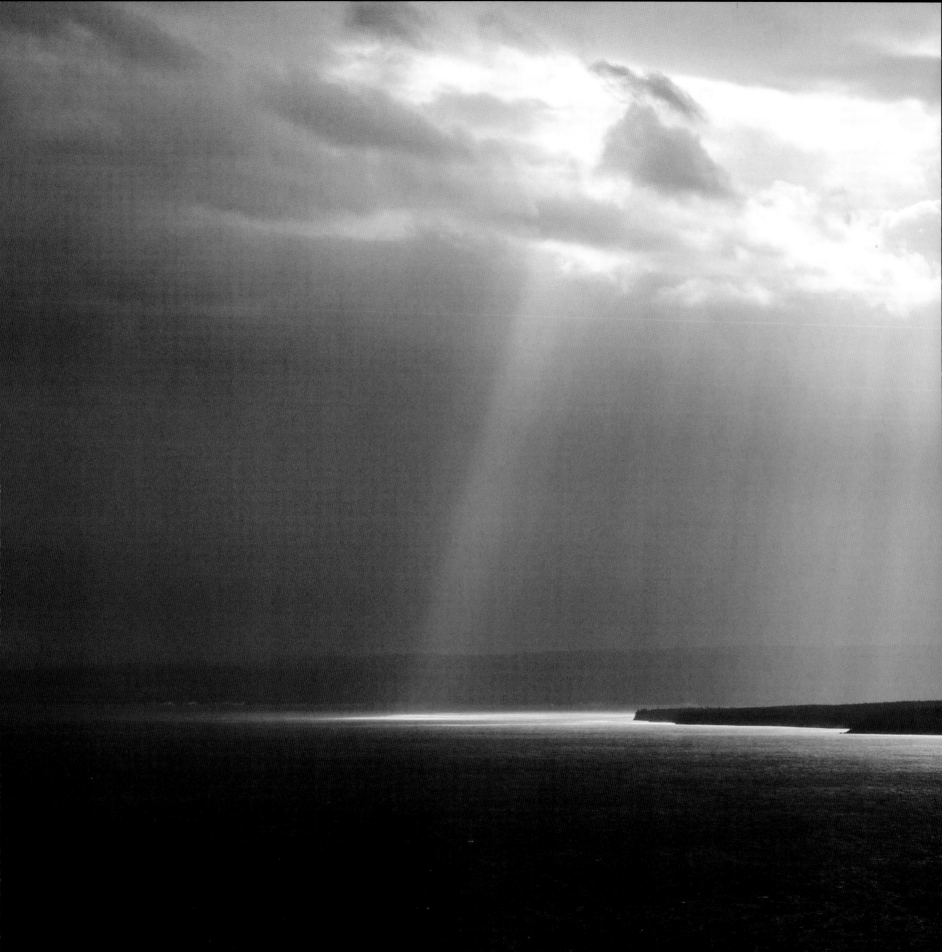

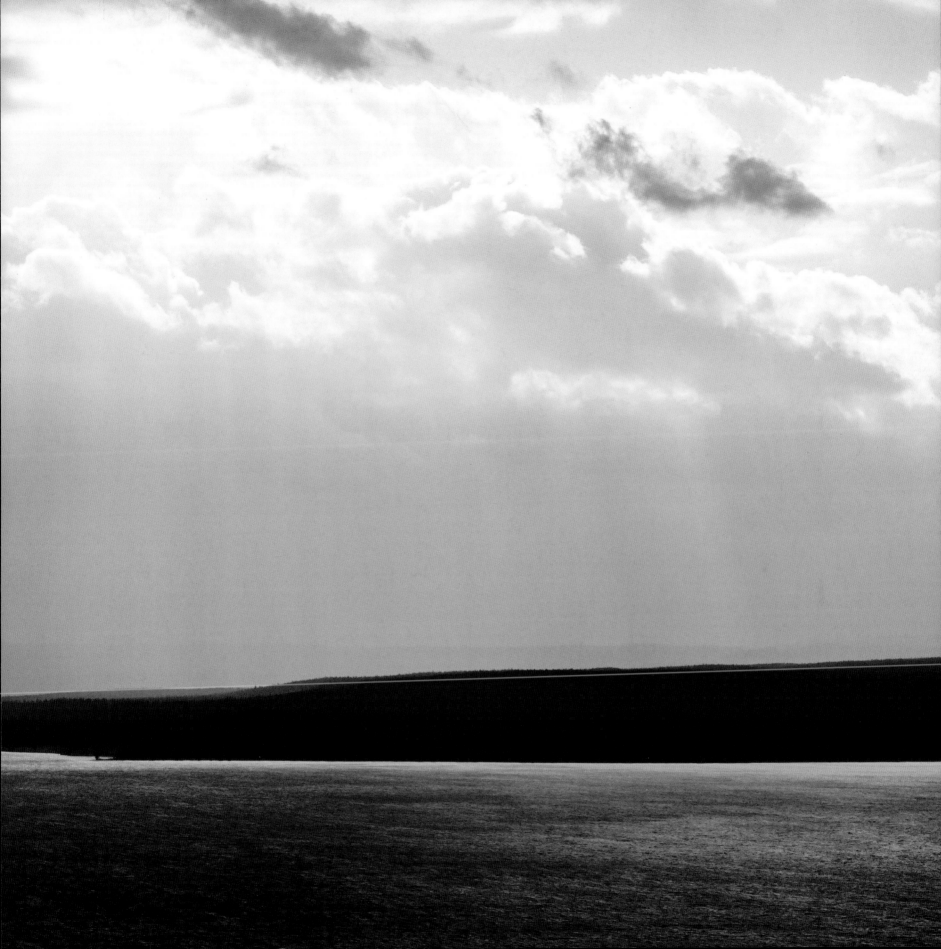

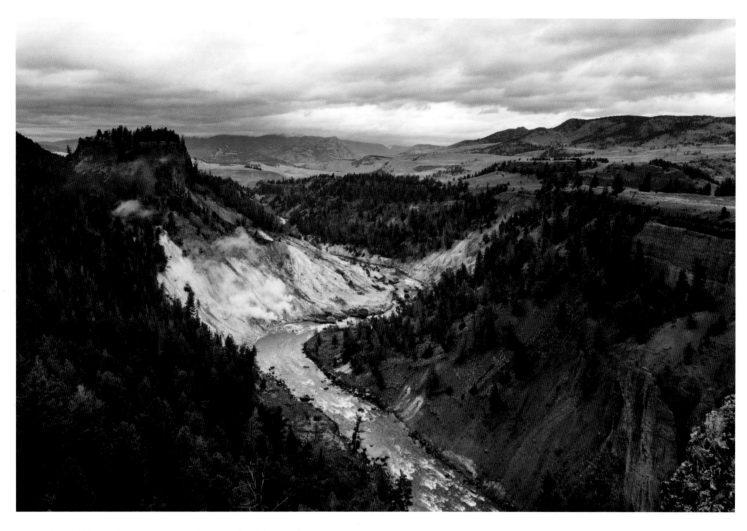

YELLOWSTONE RIVER AND CALCITE SPRINGS

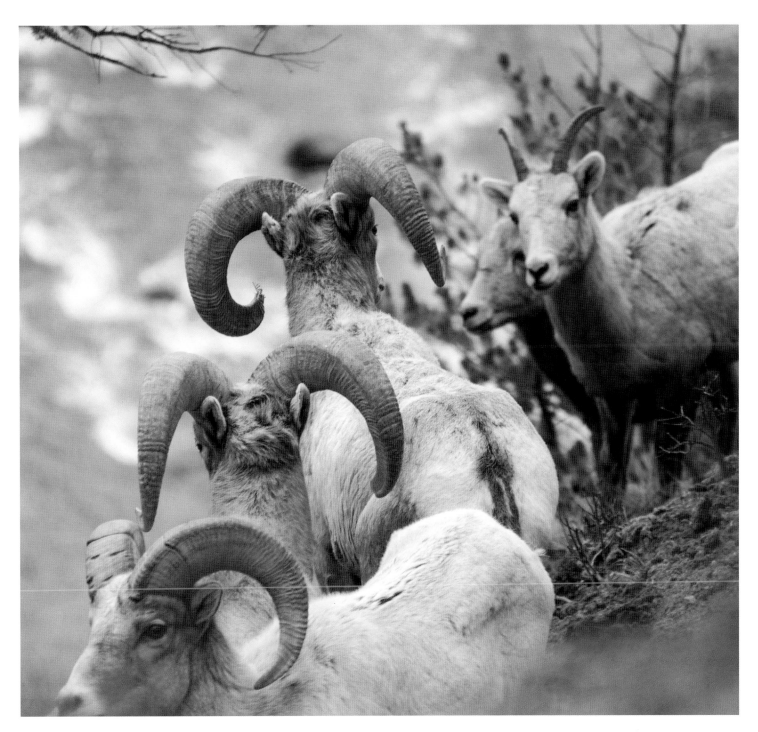

BIGHORN SHEEP ABOVE THE YELLOWSTONE RIVER

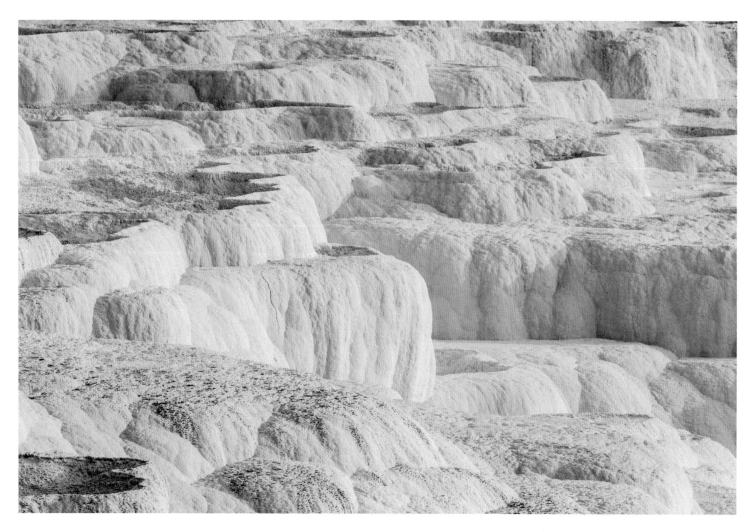

MAIN TERRACE, MAMMOTH HOT SPRINGS

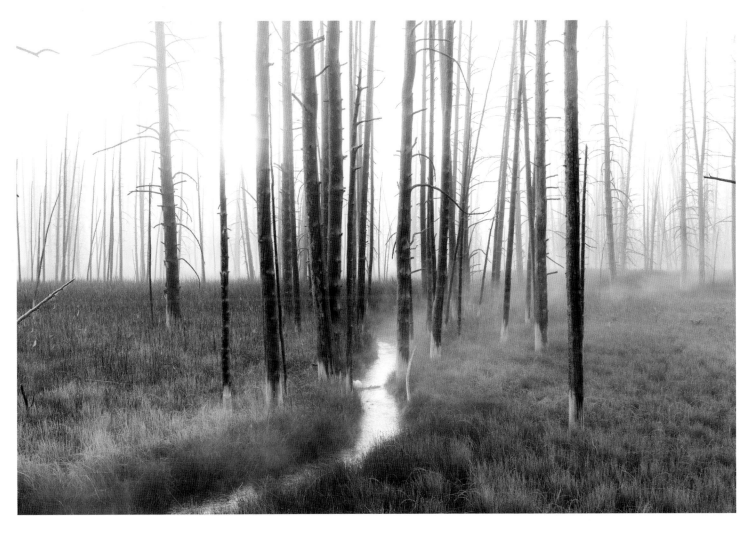

"BOBBY SOCKS" TREES, LOWER GEYSER BASIN

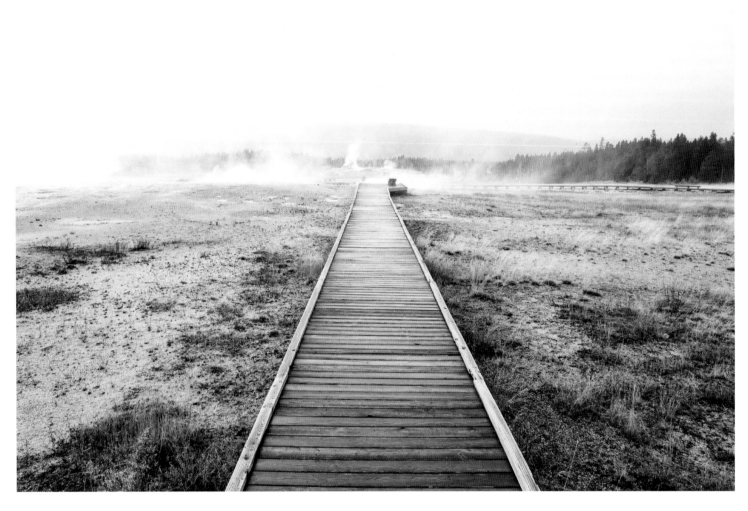

BOARDWALK, UPPER GEYSER BASIN

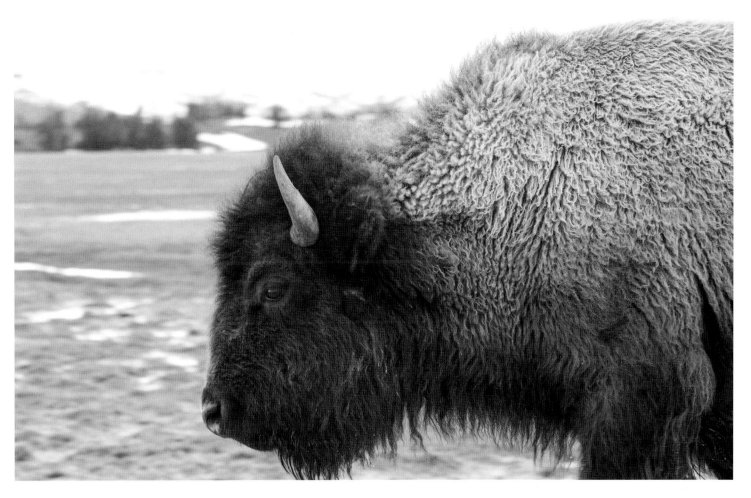

BISON NEAR MAMMOTH HOT SPRINGS

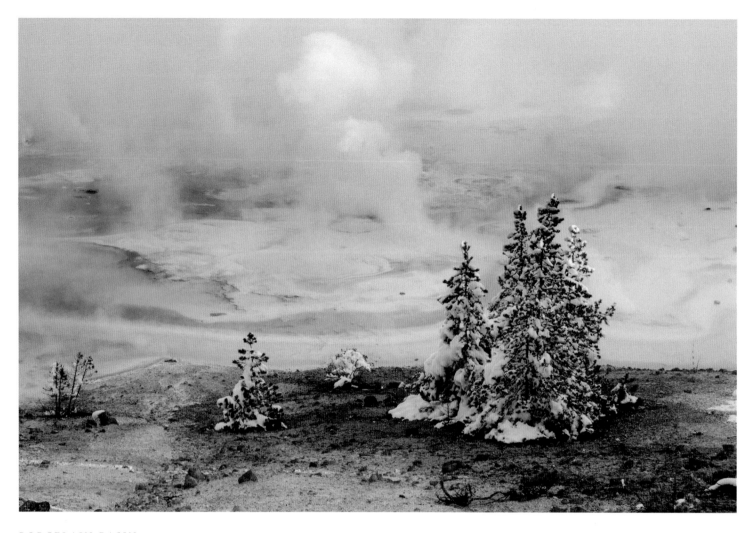

PORCELAIN BASIN

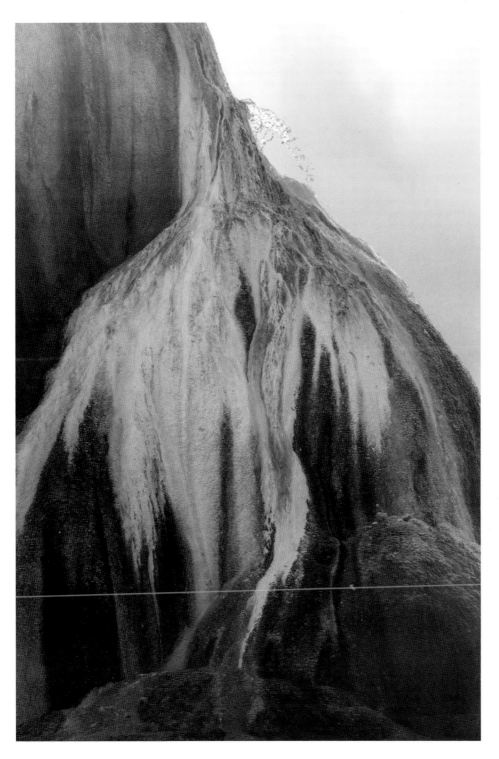

ORANGE SPRING MOUND,
MAMMOTH HOT SPRINGS

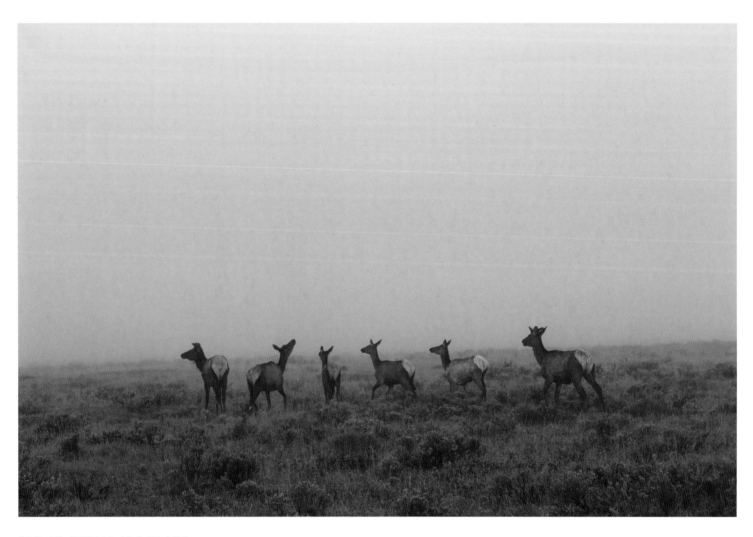

ELK AT SWAN LAKE FLATS

ABOUT THE PHOTOGRAPHER

Christopher Cauble grew up in Helena, Montana, where he began his passion for photography by exploring the local mountains with a 35mm film camera passed down from his parents. After graduating from the University of Montana with a bachelor's degree in geography, he became a freelance photographer working mostly in Montana and Yellowstone National Park. His work has been featured in magazines and books, including *A Montana Journal* and the popular children's book, *What I Saw In Yellowstone*. Cauble is also a dedicated nature cinematographer and his videos have been published on many national and international news sites and television programs. He lives near Yellowstone in Livingston, Montana, with his wife, Sarah. His work can be found on his website, www.caublephotography.com and on social media.

ACKNOWLEDGMENTS

I am grateful to the National Park Service and its dedicated rangers and biologists for their work and research in preserving Yellowstone National Park. Also for the books, maps, and programs of the Yellowstone Association that have been invaluable in expanding my knowledge of all aspects of Yellowstone.

I would not have such a deep, abiding love for wild places without the early influence of my parents, who took me to Yellowstone at an early age. I want to thank them for a lifetime of guidance, patience, and for always believing in me. Additionally, I'm fortunate to be surrounded by wonderful family and friends who continue to inspire me. And especially, I am forever grateful to my beautiful wife, Sarah. I want to thank her for her endless love, support, and encouragement, and whose design skills helped make this book come to life.